FIFE

FIFE

IMAGES BY LIZ HANSON

AND A SHORT HISTORY BY ALISTAIR MOFFAT

DEERPARK PRESS

SELKIRK

ENDPAPERS
Coal dust on the sand

First published in Great Britain in 2007 by
Deerpark Press
The Henhouse
Selkirk TD7 5EY

Photographs © Liz Hanson
Text © Alistair Moffat

ISBN 13: 978-0-9541979-5-7

Design by Mark Blackadder
Edited by Kate Blackadder

Printed and bound in China through Worldprint Limited

DEDICATION

'This book is dedicated to my mother, Mary Hanson;
a reminder of happy days spent together.

6

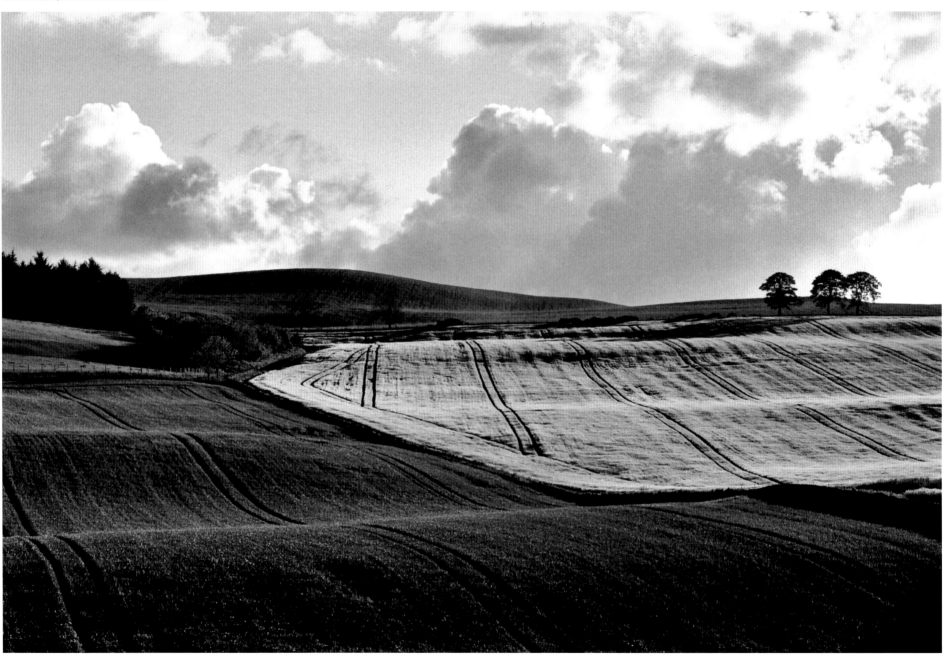

The immense and cataclysmic convulsions of the deep geological past are difficult to imagine. As continents drifted across vanished primeval oceans, as earthquakes shuddered and volcanoes flared through the earth's crust, history was beginning. And it was not a past disconnected or unrelated to the peaceful rhythms of the present age, but the beginning of our history.

Over hundreds of millions of years all manner of plants and creatures grew on the Earth, had their time and became extinct, sometimes in spasms of violent change. All that long time ago what became Europe, Scotland and Fife was slowly growing. The coal deposits so important in the last two centuries were being laid down and the free-draining rocks that would lie under fertile farmland were settling. The most recent cataclysm, the last ice age, only drew to a close 11,000 years ago, little more than a moment in the vast span of geological time. But when the glaciers rumbled down from the great ice-dome over Rannoch Moor and ground their way eastwards, they were shaping Fife, scraping and dumping debris over the face of the land, breaking open water courses, filling lochs, laying down many of the features we recognise today. Geology and weather forms the land and the land forms the character of the people. And in Fife geology has made history directly, and that history has fermented a unique and pungent identity.

Nowhere else in Scotland calls itself a kingdom. Nowhere else is there a sufficient mixture of thrawn pride, cheek and sheer character to arrogate such a title. But the map seems to justify it. In the north and south the Firths of Tay and Forth are clear, definite boundaries. The Fife peninsula has 185 kilometres of sea-coast on three sides. Until 1964 car drivers needed to board a ferry to enter the kingdom, and seen from the Lothian side the towns strung out along the southern

shore seem to resemble a rampart. For many centuries armies marching north were forced to bypass the wealth of Fife as they filed through the Stirling Gap and on to the high country beyond. In its dazzling detail and variety, Fife can seem a place apart, somewhere emphatically separate. Farming and fruit growing in the lush fields of the Howe, coal mining and heavy industry in the south-west, fishing out of the ports of the East Neuk and at St Andrews the oldest university and the greatest game. Why would anyone need to look beyond Fife's borders? All the world is there.

Yet the kingdom is central. It lies at the eastern end of Scotland's Midland Valley, is not really remote and its people are Scots to their historical core. One of the very earliest clear references to Fifers is from a poem composed around AD600 in the Lothians. It sings of the Kindred Hounds, close allies and relatives. When the Lothian kings rode south to battle against the invading English, warbands sailed across the great firth to join them.

Another, much more recent battle showed that the Kindred Hounds had retained all that ancient pride and prowess, but while empathy and support were one thing, independence was another entirely. In 1973-75 Fife fought hard and kept its freedom in the face of government plans to split it between Tayside and Lothian in one of the periodic reorganisations of local government. The kingdom endured. And in a second assault, it triumphed. Another set of changes saw Fife become the dominant authority, and not an entity based on the main population centres of Kirkcaldy and Dunfermline.

The name of the kingdom is old – but mysterious. Often attributed to St Columba, but probably later, a passage of poetry lists the provinces of Pictland. Perhaps a 7th century date might be attached. Fib and Fothreve must have been one of the richest provinces. Fothreve is generally understood as an ancient name for Kinross and West Fife. And Fib (sometimes Fiobh, and in Celtic languages bh stands for an f sound) clearly changed only a little to become Fife. Its meaning is unclear. Like Lothian, Fife may be a name deriving from an early ancestor, a Pictish prince, or perhaps even a divine forebear. Vip was a Pictish royal personal name and as part of a Roman inscription found in Colchester, it appears as Vepogen which probably means born in Fife. Already people were proud of the place.

However all that may be, one thing is unarguable. Fife has been Fife for a very long time.

• • •

Laurentia, Gondwanaland, Baltica and the Iapetus Ocean are not the inventions of science fiction, they

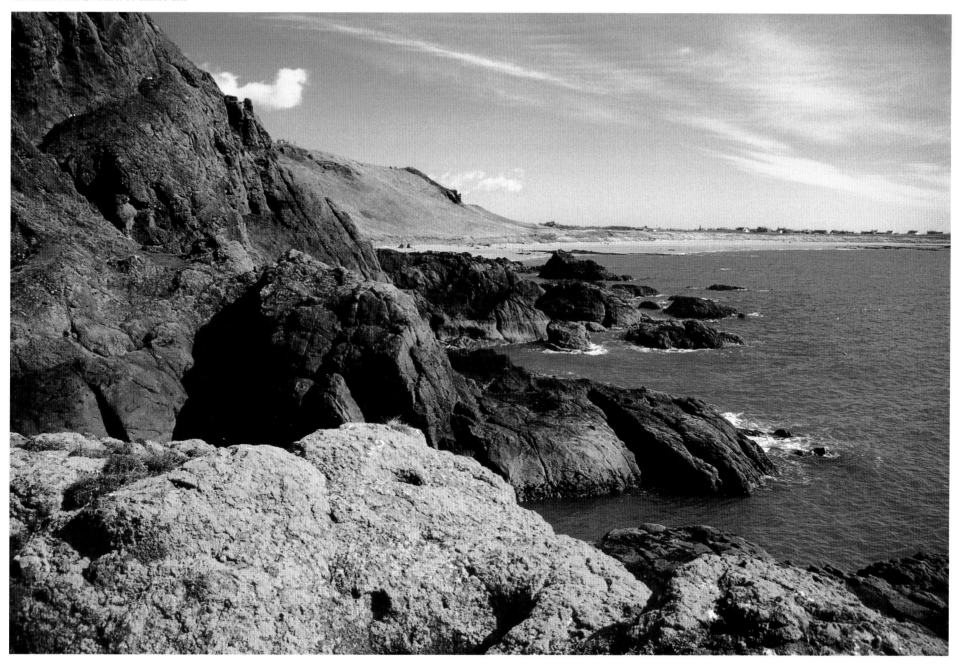

describe how the world's geography was once arranged. Between 600 and 420 million years ago, all of the present continents were combined into these three great prehistoric landmasses and divided by a vast ocean. What was to become Scotland was then a small island, close to the long shores of Laurentia. Around 4,000 kilometres to the south lay England, another island, in an archipelago fringing great Gondwanaland.

The bed of the ocean began to subduct, to slide under the coastal edges of the continents. As the Iapetus shrank, tectonic plate movement pushed Laurentia and Gondwanaland ever nearer to each other. When they collided, the harder rocks of Scotland ground and scarted their way up and over the softer stone of England, making folds and ridges as they went. The join or suture-line follows the border between England and Scotland almost exactly. And the angle at which the continents met ran at a north-east to south-west axis, and that is why the grain of Scotland's geography is set in that direction. All of the major features, the Great Glen, the Highland ranges, the Highland Line, the Midland Valley and the Southern Uplands follow the same pattern – as do Fife's western and central hills.

With the disappearance of the Iapetus Ocean, the new super-continent, called Pangaea, continued to mutate, rifting and fragmenting. Scotland and England lay near the equator and about 350 million years ago what was to become the Midland Valley began to sink. Sea water broke in and for many millions of years the warm, tropical environment supported a rich habitat. As these ancient plants and animals died and were deposited on the sea-bed, Fife's coalfield was formed.

The coal and shale seams at Cowdenbeath and Lochgelly remember that long visit to the equator, and offshore at St Monans there are fossil reefs and coral limestones. The volume of coal laid down in the tropics was vast. Between 1959 and its closure in 1987, the Westfield pit alone produced a staggering 20 million tonnes.

Two million years ago Britain had drifted across the shifting surface of the Earth to find its present latitude. Now lying much further to the north, what had become a European peninsula began to experience a series of ice ages. The last of these gathered momentum around 24,000BC and temperatures dropped steadily for 6,000 years until ice covered more than a third of the Earth's surface. The Arctic conditions submerged Scotland beneath a desolate and savage white landscape. Ice-sheets reached as far down as South Wales and the English Midlands, and beyond them stretched a vast horizon of tundra. Massive ice-domes formed, several kilometres thick, and around their flanks incessant hurricanes blew. Nothing and no-one could survive in such hostile conditions, and the coming of the ice erased

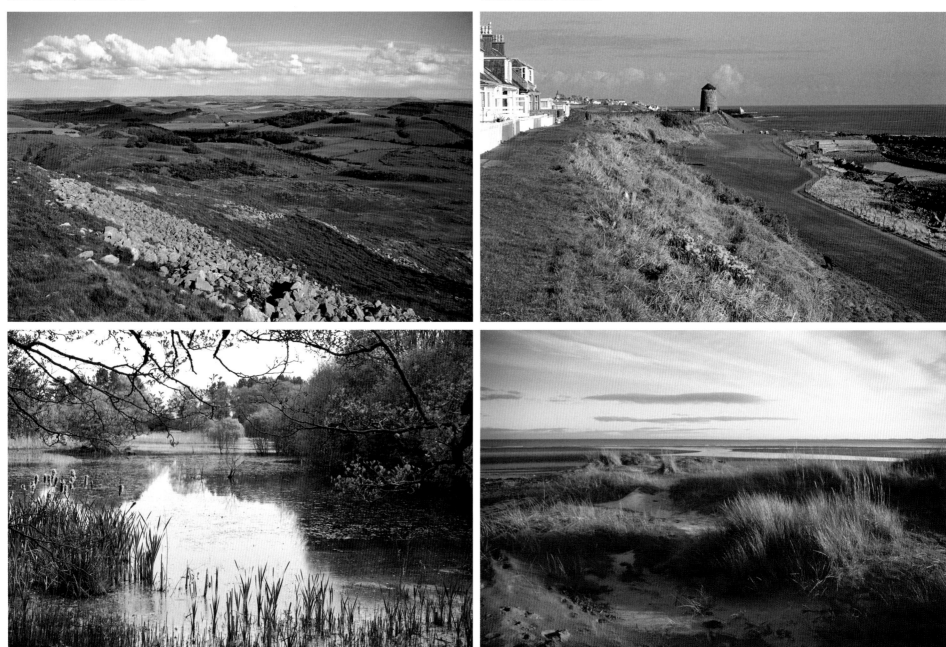

MORTON LOCHS

TENTSMUIR

any trace of human settlement in Scotland before 24,000BC.

Ice ages may well be caused by the Earth's orbit spinning slightly out of kilter, critically altering its exposure to sunlight, especially the northern hemisphere. By 11,000BC the orbit had corrected and the great domes began to groan and crack as glaciers moved slowly down them, grinding over a slick of meltwater. In a matter of only centuries, the ice retreated northwards and some historians believe that plants recolonised the ground very quickly. After grasses and herbage, small trees grew. First came dwarf willow and birch, then aspen, pine and hazel, and eventually larger and longer-living trees like oak, beech and elm. At almost the same time as the flora reappeared, the fauna who fed on it arrived. All those who grazed, browsed, burrowed, swam and flew inhabited the virgin wildwood. And close behind them prowled their predators: lynx, wolves, bears and the most dangerous of all, human beings.

Three hundred generations had lived and died since the beginning of the last ice age and over that immense period all knowledge of the north was almost certainly lost. When the ice began to retreat it is likely that bands of hunter-gatherer-fishers, probably travelling in family groups, followed it, pursuing game, fish and a wild harvest right up to its edges. On the brief summer tundra plants grew for a few weeks on the thawing ground and grazing animals like reindeer and wild horses drifted north to eat them. As they migrated, hunting bands tracked, trapped and killed them.

Around 10,000BC temperatures in Scotland rose to modern norms and the first pioneers probably travelled north on water. Canoes were the fastest and most reliable means of transport, far preferable to struggling through a tangled forest where the only tracks were made by animals, and where it was easy to get lost. The sea coast fluctuated with the long freeze and the subsequent melt, but Fife must have been an attractive and accessible early destination, even if only for summer expeditions. The sun warmed the land, trees carpeted Scotland with a virgin wildwood. Over all of Fife and far inland a temperate jungle spread, reaching up and over most high ground. On the Lomond Hills the wind could not discourage hazel and birch from growing on the summits. As far as the eye could see, a green canopy stretched away into the sunset.

But it was to be a false summer. Thousands of kilometres to the west, in northern Canada, a disaster was waiting to happen. As the ice-sheets retreated over North America, a vast lake of intensely cold freshwater built up. It covered an area much larger than the North Sea. At first it drained slowly over a rocky ridge to the south, shaping the Mississippi river system, draining

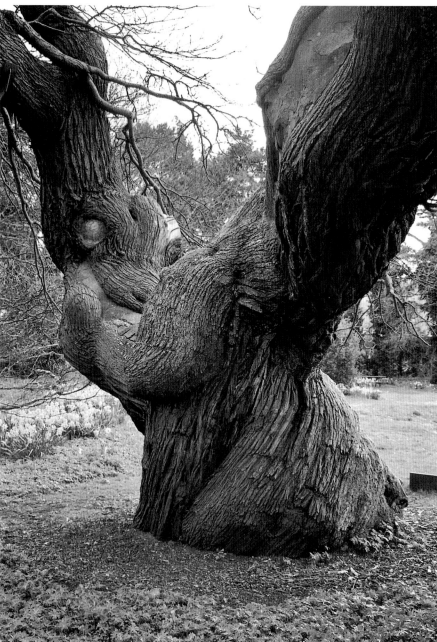

16

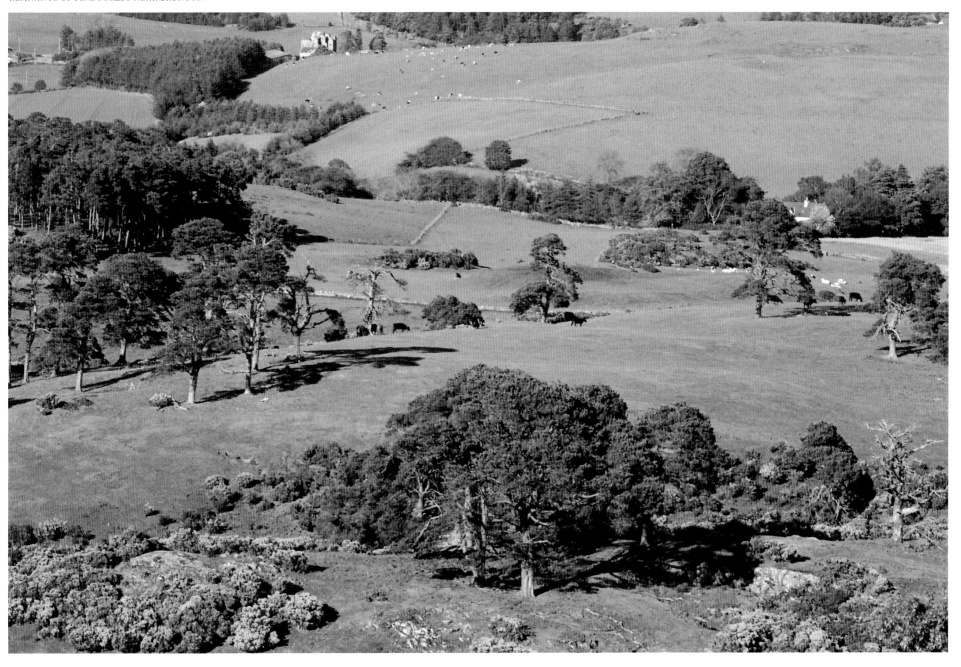

18

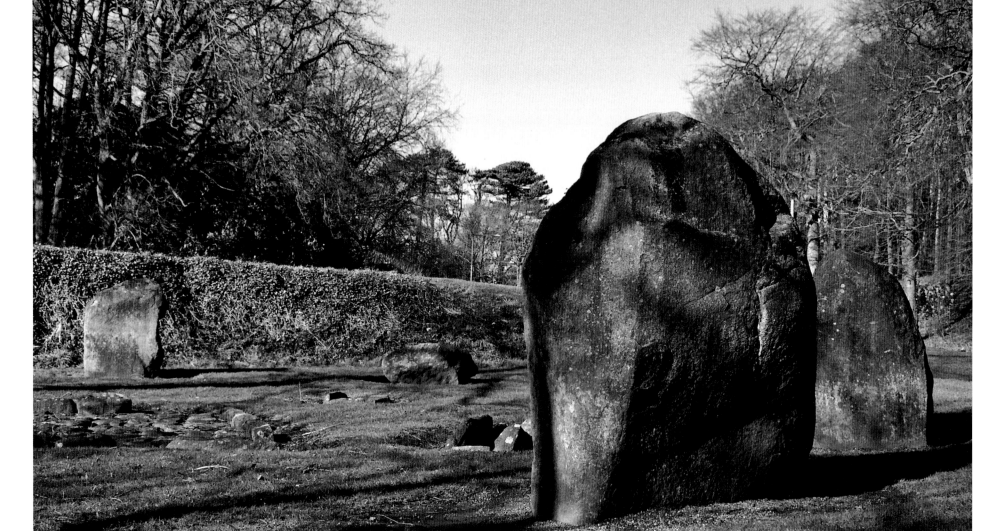

ultimately into the Gulf of Mexico. But as temperatures continued to rise, the ice-dams to the east of the vast lake suddenly disintegrated. With a tremendous roar, it broke through into the St Lawrence Basin and in a matter of only 36 hours millions of cubic kilometres of water gushed into the North Atlantic. The effect was catastrophic.

Almost instantaneously the Earth's sea-levels rose by a staggering 30 metres. Tsunamis surged towards helpless coastlines and communities were swept into oblivion. But most devastating was the dilution of the ocean with an enormous cubic tonnage of very cold freshwater. The conveyor belt of ocean circulation which carried the warm waters of the Gulf Stream northwards was stopped dead. The climate suddenly changed. Over Scotland and northern Europe storms blew once more, snow fell steadily and did not melt with the coming of summer. A vast ice-dome reformed over Ben Lomond,

the bitter cold crept back over the land and the pioneer bands fled south.

For a thousand years the Drumalban mountains lay under the crushing weight of a dense ice-sheet and the rest of Scotland withered into an Arctic tundra. Freezing winds and nine month winters made settlement impossible, but a brief summer melt might have allowed the growth of grazing, encouraged animal migration and perhaps hunting expeditions. Over fifty generations, stories and knowledge of the lands of the north before the ice might have been told and retold in the circle of firelight. Perhaps Scotland was not entirely lost in the endless snows and storms.

Eventually the waters of the vast Canadian lake were diluted, the Atlantic Ocean regained its salinity and the conveyor system brought the Gulf Stream back to northern latitudes. Temperatures rose and the summer hunters gradually became pioneer settlers.

These people came from the south, perhaps coasting up the North Sea shore, sailing in short hops between clear sea-marks. At Fife Ness, on the flat ground near the tip of this prominent headland, archaeologists have found the earliest traces of human activity yet to come to light in Fife. Some time around 7,600BC a small band of hunter-gatherer-fishers pitched camp there, perhaps after beaching and securing their boat. Only the faintest shadows of these people remain: a hearth, several pits and few discarded stone tools. It may be that only three or four people camped at Fife Ness all that long time ago, and they almost certainly arrived by sea. Prehistoric boats were of two sorts: wooden dugout canoes and the skin boats now known as curraghs and coracles. The latter are still made and rowed in the west of Ireland. Simply constructed out of a basket-like frame of green wood rods lashed together with thongs or pine tree roots and covered with a stretched and caulked hide

hull, they are usually rowed by a small crew of four and sometimes also propelled by a sail set amidships. Entirely made from organic and perishable materials, no trace remains of prehistoric curraghs but it is very likely that they were in widespread use 10,000 years ago.

The hunters at Fife Ness may have used their upturned boat as a shelter. Only staying on the windy headland for a few days, they seem to have come on a summer expedition. Archaeologists surmise that they were catching seabirds. If they came in May or early June, they will have been able to snare plump young fledglings from nesting places before they became able to fly. The men of St Kilda did the same thing until the 1930s, and from Ness in the Isle of Lewis an expedition still sails out to the uninhabited Atlantic island of Sulasgeir in the early summer. There they hunt the guga, young gannets, and bring back around 2,000. The salty flesh is an acquired taste but the guga preserve

well, either dried, smoked or soaked in brine. It may be that the camp at Fife Ness was doing exactly the same thing, gathering food to see their family band through a hungry winter.

If it was indeed an expedition, where did the hunters come from? Astonishing recent finds might well supply the answer. Archaeologists have long believed that the early peoples lived in little more than shelters, tents made from hide and pitched bender-style, stretched over stakes driven into the ground. Flitting through the wildwood, leaving only wisps and hints of their passing, the hunter-gatherer-fishers have been seen as primitive transients, survivors, living literally from hand to mouth. That primordial picture now needs to be repainted in the light of two remarkable discoveries. At Howick Haven, on the Northumberland coast, a substantial wooden house dating to 7,700BC to 7,600BC has been found. And in 2002 another big house was

found at East Barns, on the coast of East Lothian, not far from Dunbar. It may have been slightly older than the Howick house.

Both were made from massive timbers, probably trimmed tree trunks, dug and packed into post-holes and arranged like an American Indian tipi and roofed with turf and heather or bracken. Very much more substantial than any bender tent, these houses were big enough to accommodate a family of eight or ten, and it looks as though they were permanent buildings intended for year-round use. Such was the investment of time and labour, that the East Barns and Howick houses also imply ownership of land, certainly in the vicinity and probably customary rights over a wider area. It may well be that the Fife Ness expedition set out from the East Lothian shore.

As the weather continued to improve and more pioneers ventured north, more of Scotland was

CULROSS WITH 16TH CENTURY PALACE IN FOREGROUND

TANHOUSE BRAE, CULROSS

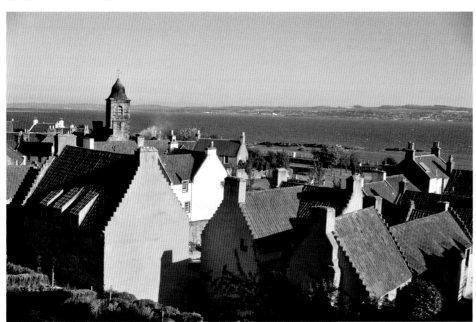
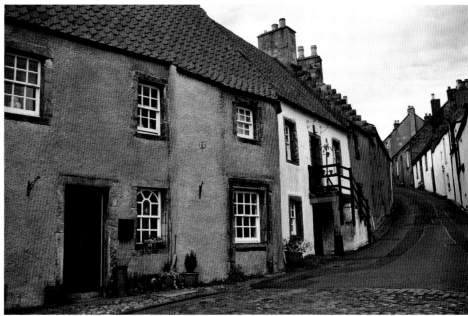

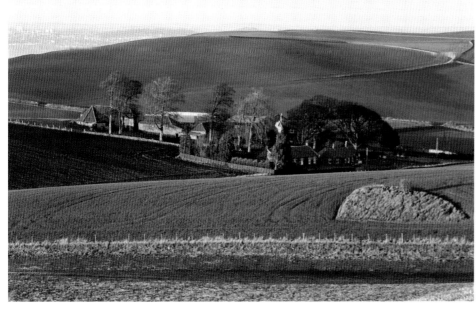
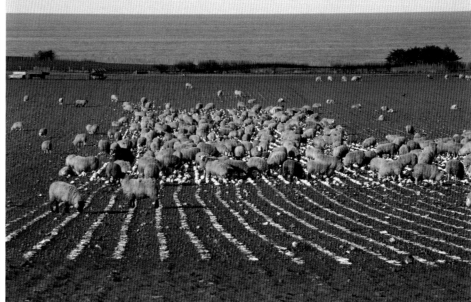

PITTACHOPE, NORTH FIFE

TURNIP FIELD NEAR KINGSBARNS

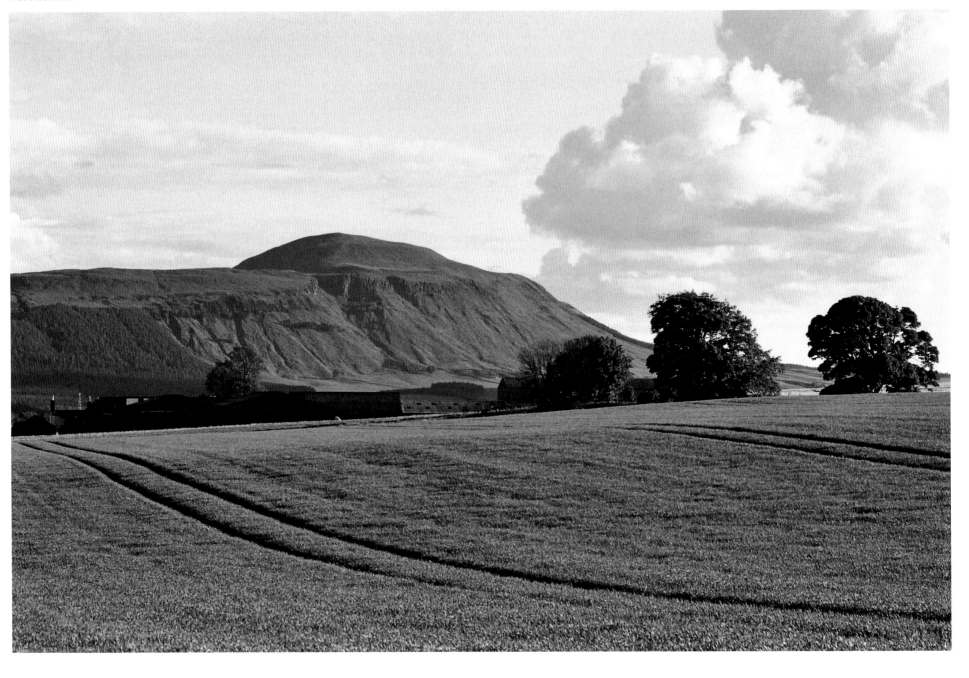

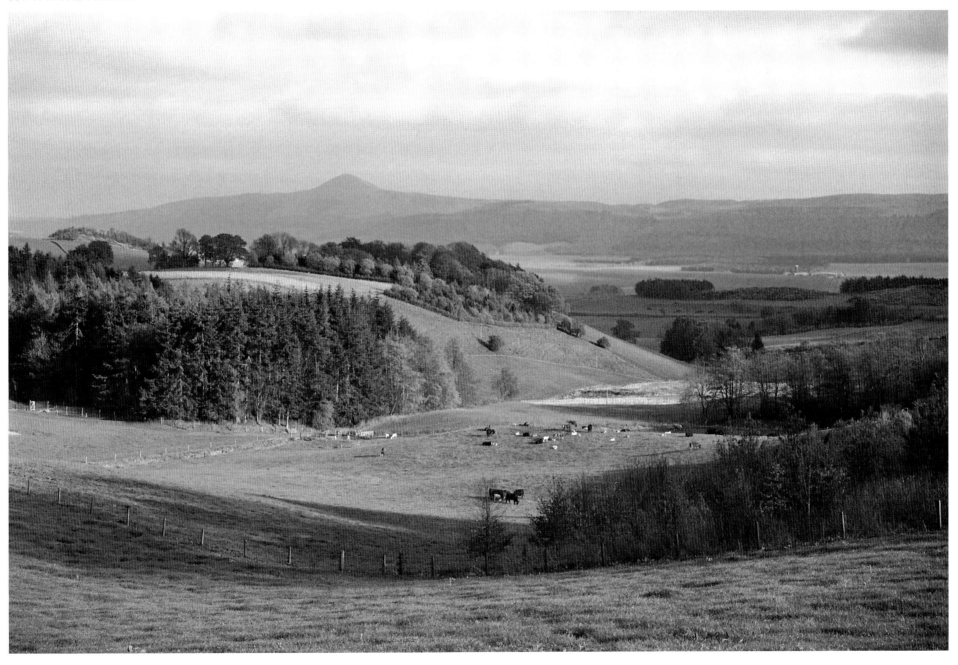

24

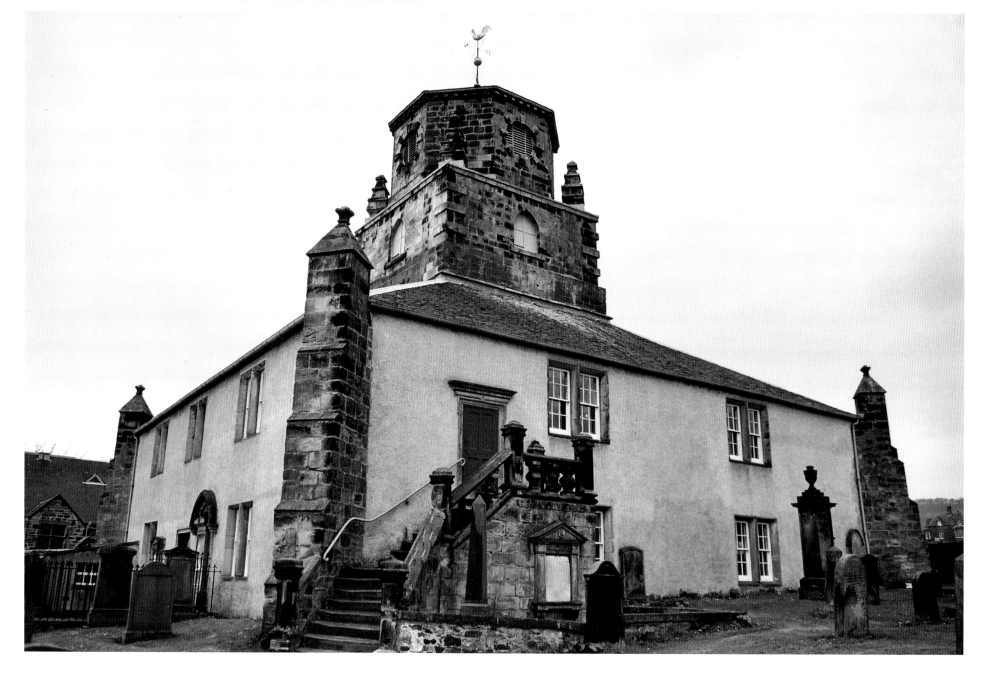

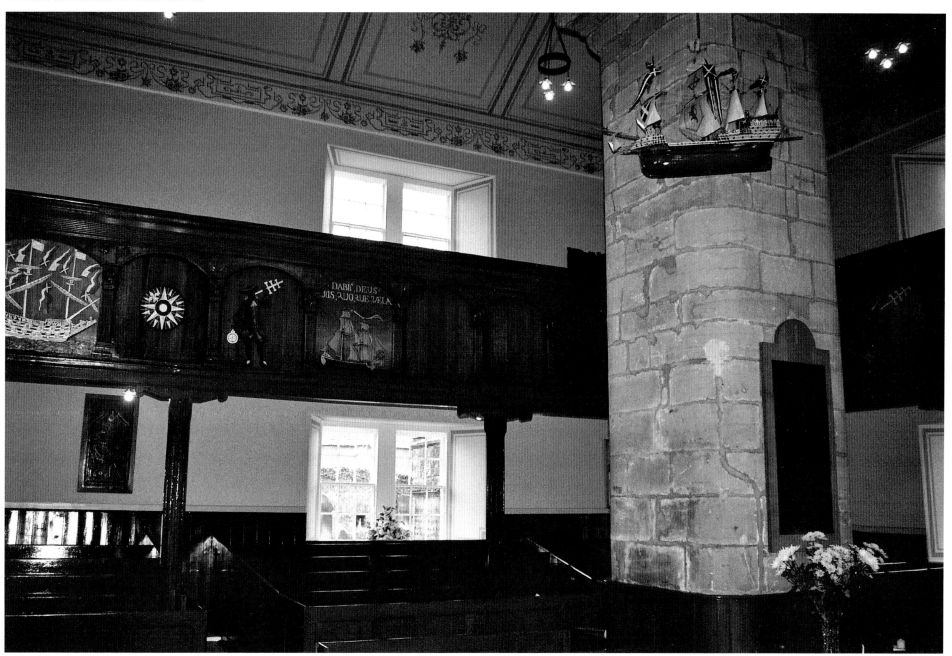

25

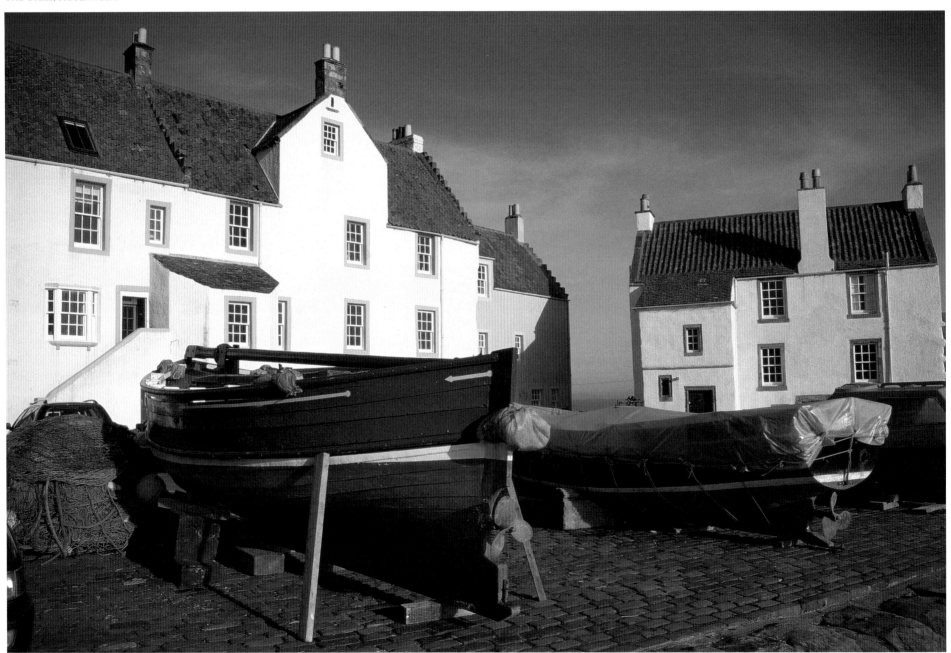

rediscovered. Population pressure pushed the edges of knowledge further north and further inland. A hunter-gatherer-fisher band needed a wide area of land and seashore to sustain itself. The supply of firewood, for example, was critical and could be easily exhausted if not properly husbanded and the older children of family bands needed to move on to find marriage partners. For these reasons, summer camps could quickly evolve into permanent settlements. Tools made and used at this time in Fife have been found as far inland as Blebocraigs and Strathmiglo.

The seashore offered the most attractive place for settlement. Three habitats – the wildwood, the shoreline and the sea itself – meet there and allow communities to support themselves all year round. When the wild harvest of berries, fruits, nuts, fungi and roots had been gathered in by autumn (and much of it dried or roasted and then stored) and summer hunting parties had

brought back their bounty, hunter-gatherers became fishers and looked to the sea for meat. And probably an area patrolled by children with baskets and bags, the sea shore could be gleaned for cockles, mussels, crabs, razors and much else. If a colony of seals basked nearby, a determined band could catch and kill them before they slithered into the safety of the water.

For all these reasons, a group of the early peoples settled at Morton, near Tayport. The site of their hamlet is now four kilometres from the sea, but levels fluctuated a good deal in the prehistoric period and archaeologists have been able to show that Morton was a tidal islet lying just offshore around 6,000BC. In addition to middens of shells, fishbones and other debris, there were several shelters and windbreaks – nothing on the scale of East Barns or Howick, but leaving a clear pattern on the ground nonetheless. Probably because of its seaside location, Morton seems to have been occupied in the

winter. Analysis of bones and stone tools show a mobile group. In summer they hunted as far west as the Ochil Hills, went inland along Stratheden and down the coast at least to the area around St Andrews. It seems likely that Morton was an outlier, a temporary camp belonging to a larger settlement. Perhaps it lay inland where trees and other building materials were more readily available.

Some time around 5,840BC the people who lived in the shelters at Morton would have seen something extraordinary. With a tremendous rushing noise, the sea suddenly retreated, revealing vast areas of the bed, leaving fish flapping and boats stranded. Five hundred kilometres to the north-east, in the black-dark trench known as the Norway Deeps, an earthquake cracked open the continental crust and a huge tonnage of the sea-bed was sucked downwards. The momentary vacuum caused the North Sea to drain into the void and retreat rapidly from every shoreline. Those watching at

Morton and all along the Fife coast will have stood open-mouthed in bewilderment. Was the world ending?

It was about to. The seabirds heard it first. A mighty roar boomed across the sea as a tsunami came racing towards the coast at an extraordinary speed of 480 kilometres an hour. It smashed into the Fife coast, snapping trees like matchsticks, killing every living thing in its path. The giant wave carried a deadly freight of boulders and gravel and as this tore up the Tay and Forth estuaries, it will have obliterated many settlements, erasing the archaeological record as surely as an ice-age glacier. Inside it the tsunami also brought white pelagic sand, the sort only found far out at sea, and when archaeologists found deposits of this all around the Fife coast, at Morton, Broughty Ferry and along the northern shore of the Tay, they realised what had happened – and could also date it accurately.

The devastation on the Fife coast doubtless took generations to repair. But for a remarkable – and entirely forgotten place – it may have been a terminal disaster.

At the height of the last ice-age, the great domes pressed hard on the land under them. Several kilometres thick, their crushing weight depressed much of the Earth's crust in the north. Central Sweden, for example, was 800 metres lower than it is now. The ice had the effect of creating a forebulge, that is, it lifted areas to the south much higher than they are now. The effect can be compared to a fat man sitting on half of a cushion.

In the millennia following the retreat of the ice the southern basin of the North Sea was no such thing. South of a line drawn from northern Denmark to the Northumberland coast, much of this enormous area was dry land. It is widely understood that Britain was connected to Europe by a landbridge in the prehistoric period. Recent research has shown that much more than a bridge, this place was in fact a sub-continent, an ancient Atlantis now lost beneath the waves.

Out in the North Sea there exists a famous fishing ground, an area of shallow water known as the Dogger Bank. In fact it is not a sandbank but the tops of a range of undersea hills, the northern border of a vast submerged subcontinent. Archaeologists have called it Doggerland, and its hundreds of bays, estuaries and long shoreline were home to many hunter-gatherer-fisher bands. Some believe that it was the cradle of early prehistoric society in north-west Europe.

When the great tsunami hit in 5,840BC, the impact on Doggerland was especially devastating. It almost certainly reduced it to a large island as the areas to the east, south and west were inundated. Survivors may have taken to their boats at this time and some no doubt fetched up on a Fife shore – a comforting thought to set alongside the fact that most of the

LOOKING TOWARDS ANSTRUTHER

BOARHILLS

FARMLAND BETWEEN DUNFERMLINE AND CROSSFORD

ABDEN, NEAR KINGHORN

kingdom's early settlers came up from the south, from what is now England.

As the Earth's crust bounced back after the lifting of the weight of the ice in the north, Doggerland by contrast slowly submerged and the eastern coastline of Scotland began to assume its present shape. The stage was set for the most important change in human society, paradoxically a mysterious process poorly understood by historians.

Some time in the 4th millennium BC farming came to Fife. And it changed the prehistoric way of life entirely. How exactly this happened, the precise mechanics of this great change, are not well understood. The historian and geneticist, Professor Bryan Sykes, has analysed sequences of mitochondrial DNA in Britain and Europe and has detected an influx of new people, about 20% of the population, around this time. Farming began in the Fertile Crescent, mostly in present-day Iraq, and Sykes believes that people moved slowly westwards bringing these new ideas and new ways of growing and rearing food with them. Certainly communities passed on plant-seeds, particularly the wild grasses which had been modified into the range of cereals still grown now, and domesticated animals were also moved from one place to another. If Britain had lost its land link with Europe by, say, 4,000BC, then these ideas, seeds and animals will have come by boat.

In any event, farming changed the way in which people thought. Hunter-gatherer-fishers almost certainly held customary rights to tracts of land, but farmers came more definitely to own them. All of the labour necessarily invested in clearing woodland and scrub, in tilling, planting, weeding and harvesting small fields certainly implied commitment and equally certainly involved a sense of ownership. Inevitably that will have brought dispute (not all land was cultivable, some drained better, was sheltered and south-facing or more convenient) and probably conflict. The world was never Edenic. Men and women have always fought with each other, on some pretext or other, but the need to protect and hold on to land created an inevitable need for more organisation, perhaps even for specialised military skills.

Few traces of prehistoric farms have survived in Fife, many have of course been obliterated by later land-use, but a fascinating monument erected by groups of very early farmers has come down to us. At Balfarg, near Glenrothes, archaeologists have been able to piece together how they treated their dead – and from that some very limited sense of how they thought and how they saw the world can be guessed at.

Dating to around 3,700BC, an oblong wooden enclosure was built out of posts. Its shape may have mimicked the look of contemporary houses, but what

the prehistoric peoples of central Fife built was a house for the dead, and not the living. Inside the enclosure stood a series of flat platforms raised on high stilts. Protected by their fence of stakes, they were designed to discourage wolves, lynx, bears and other meat-eating predators. For these were the towers of the dead. Or excarnation platforms, according to archaeologists. It seems that the early farmers brought their dead, or at any rate their important dead, (not everyone can have been accorded this treatment) and laid up their bodies on the high wooden structures. No doubt this was done with ceremony of some unknowable sort, but the purpose of the enclosure was simple. Carrion-eating birds were encouraged to come and pick the bones clean, but were not able to carry them off as wolves might do. This was done because the bones were important in some way.

American Indians also exposed their dead on excarnation platforms in the 19th century and the religious rationale was recorded by Europeans. When an important person died, it was thought that their breath-soul left their body but their dream-soul lived on in their flesh and organs. Once the birds had pecked off the last gobbets of tissue (and there is some evidence that the skeletons were left for a time for all the flesh to perish and the bones to weather), it was thought that the dream-soul was at last released. At some propitious moment in the calendar the remains were taken down off the platforms and probably buried or possibly cremated and the ash buried or cast to the winds.

To the prehistoric peoples, these ceremonies and all the time and care they took were much more than mere mindless ritual. The dead made life possible. Where they were buried and celebrated marked and emphasised the historic ownership of land. The burial of the dead, their literal planting in it legitimised its ownership by the living, their desecendants. There is an eloquent example of this way of thinking on the Orkney island of Rousay. There prehistoric remains have survived in quantity and quality because they were made from stone, trees being scarce. And on Rousay there are 13 chambered stone cairns containing the bones of the prehistoric dead. Correlating almost exactly, there were 13 farms on the island up until the 19th century.

So that others could see the monuments to the dead and make the connection with the ownership of the land around or near them, many were carefully sited to be easily visible, or they lay on the edges of territory as some sort of frontier marking. In the south of England archaeologists have noticed that even elaborate monuments are sometimes placed in liminal areas, border-places between tracts of valuable land. One of these signal locations survives in central Fife. In the 2nd millennium BC a burial cairn was raised on the high

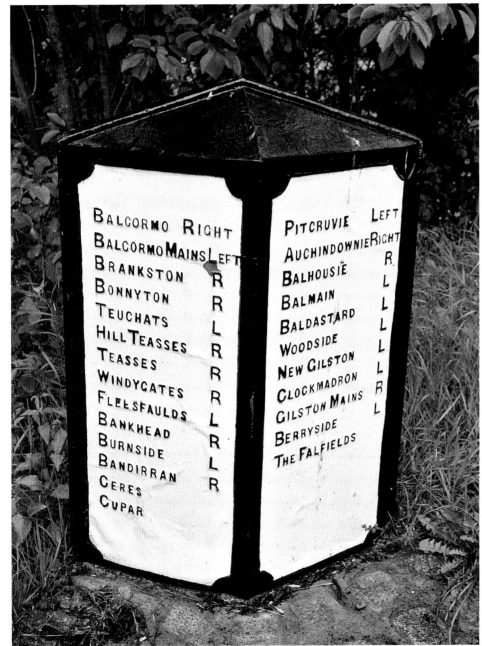

ground at Foxton, above the Eden Valley. From long distances, the site is clearly visible and it lies almost exactly on the eastern boundary of the parish of Cupar. Almost certainly the boundary remembers a much more ancient division, perhaps where two prehistoric tribes shared a border.

In Fife an uncountable number of conspicuous ceremonial sites made by the early farmers have disappeared for the excellent reason that they were constructed out of wood. Orkney is unusual in having so many survivors and that accident of history and environment skews the picture somewhat, leading us to believe that there was a more vibrant, even more successful prehistoric culture in the Northern Isles. There is no reason to suppose that this was so. The largest henge yet found in Scotland stood at Dunragit, near Stranraer, but no trace can be seen because its builders used trees to form it.

A henge replaced or augmented the excarnation platforms at Balfarg around 3,100BC. What this means is something straightforward. Unlike the massive and extremely unusual stone circle at Stonehenge, a henge was often a simple bank made from the upcast of a circular ditch. Sometimes there were two banks with a ditch between, and usually the circle was small. At Balfarg it measured only 20 metres across.

The ceremonies which took place inside henges have of course long vanished into the darkness of the past. No-one can now know what took place. One historian compared the process of conjecture with attempting to work out the details of medieval Christian liturgy from looking at the ruins of one of the Border abbeys. But some general observations are possible and worthwhile.

At Balfarg the henge saw ceremonies of some kind, probably what we might call religious ceremonies

although the meaning of that phrase is capable of countless interpretations. These probably involved gatherings of local people and at pre-ordained times, perhaps the turning points of the agricultural year. The nature of henges involve some sense of inside/outside, an idea now carried by the Christian phrase sanctum sanctorum, the holy of holies. The circular area enclosed by banks and a ditch was holier than the area outside it. Otherwise why demarcate it? That in turn implies mystery. Perhaps some people were excluded and only important or specially chosen people admitted. For most of the entire history of the Christian priesthood, mass was said behind a screen raised across the nave of a church. Priests celebrated the mystery and the laity could hear but not see it.

Processions and music may also have been involved. The drama of religious rites often demands such preliminaries, what is known in the realm of sport

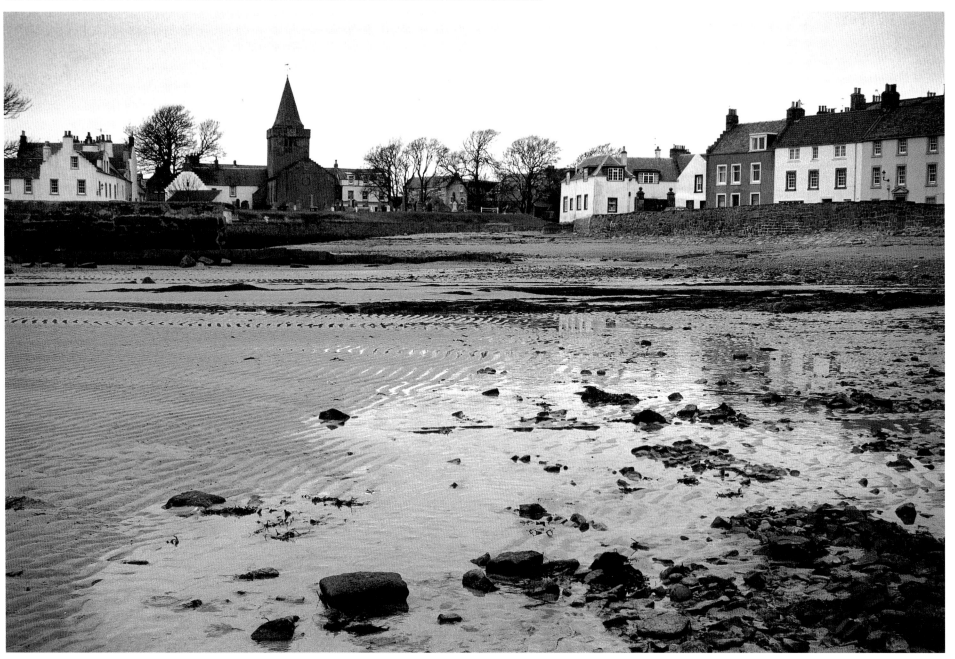

as a build-up, but all of the details of this are of course lost. One discovery at Balfarg does shine a momentary light on the nature of what went on. On a piece of pottery traces of the drug known as henbane were found encrusted. It is a powerful hallucinogenic. Perhaps dancing and trances formed part of the ceremonial, perhaps priests used drugs to find a way to the minds of the gods and interpret their thoughts to their people. It is impossible to do more than speculate. But one compelling theory developed by Irish archaeologists is attractive. They hold that henges were prisons, corralls where evil spirits were kept penned behind the ditch and banks and separate from the living world around them.

Balfarg formed part of a complex of ceremonial sites in central Fife. At nearby Balbirnie, there was a substantial stone circle and there may have been two others at Balfarg where a much larger henge was dug to accommodate them. Between 3,100BC and around 1,400BC, these monuments stood at the centre of the lives of the local prehistoric peoples. At Lundin Links and at Dunino there were more modest stone circles probably forming a part of smaller sacred landscapes.

In their way prehistoric monuments are as much a testament to wealth and hard work as the great medieval churches and cathedrals. The communities of farmers who laboured in work gangs with picks, scoops and baskets had already produced a surplus of food sufficient to sustain such non-productive work. And building a henge required organisation which implies a political structure of some sort, probably a network of tribal and sub-tribal kindred groups. A large complex like Balfarg also strongly suggests a powerful directing mind, perhaps a single individual like a priest-king, or perhaps a priestly caste.

In common with the rest of prehistoric Britain, Fife saw the gradual emergence of an aristocracy. Burial shows this well. At Balfarg cist graves begin to appear around 2,000BC. These stone-lined coffins sunk into the ground contain only one body, and at first they were set in a crouched, foetal position with the knees tucked up. Several cists are sometimes found on one site, such as Dalgety Bay, and when the grave-site or cemetery was somehow thought to be complete, it was often covered by a cairn. Like the other monuments, it was easily seen from a distance. One of the largest and certainly the highest cairn in Fife is on the summit of East Lomond Hill. There are others on Pitcairn and Norrie's Law.

Between 1,800BC and 1,400BC cremation begins to appear in the archaeological record. Ashes were packed into decorated pottery urns and buried upside down in cemeteries known as urnfields. This expensive and laborious funerary practice reinforces a sense of the emergence of an aristocracy. Intense heat is needed to

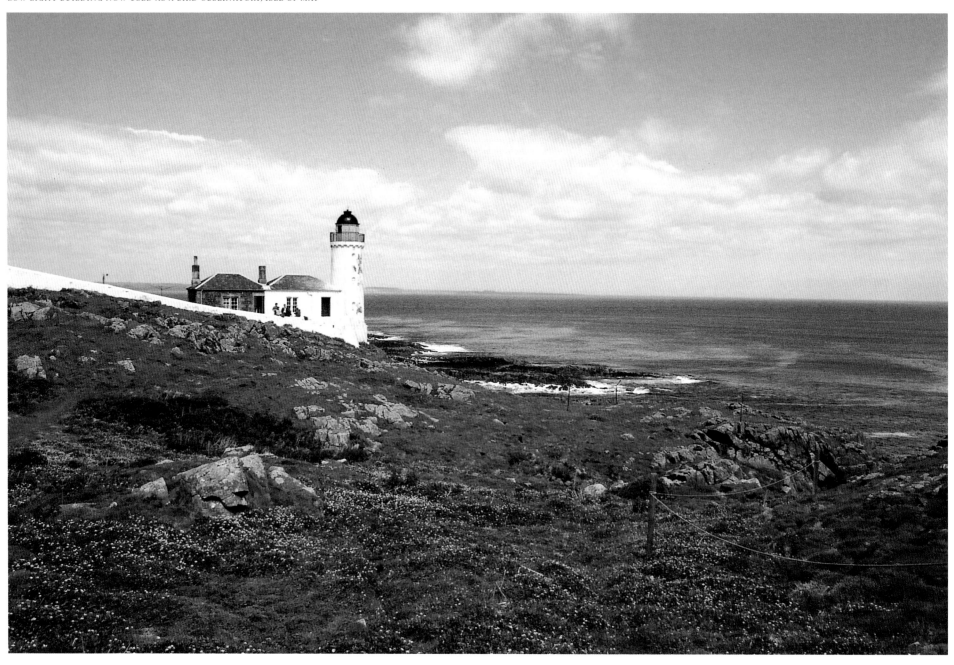

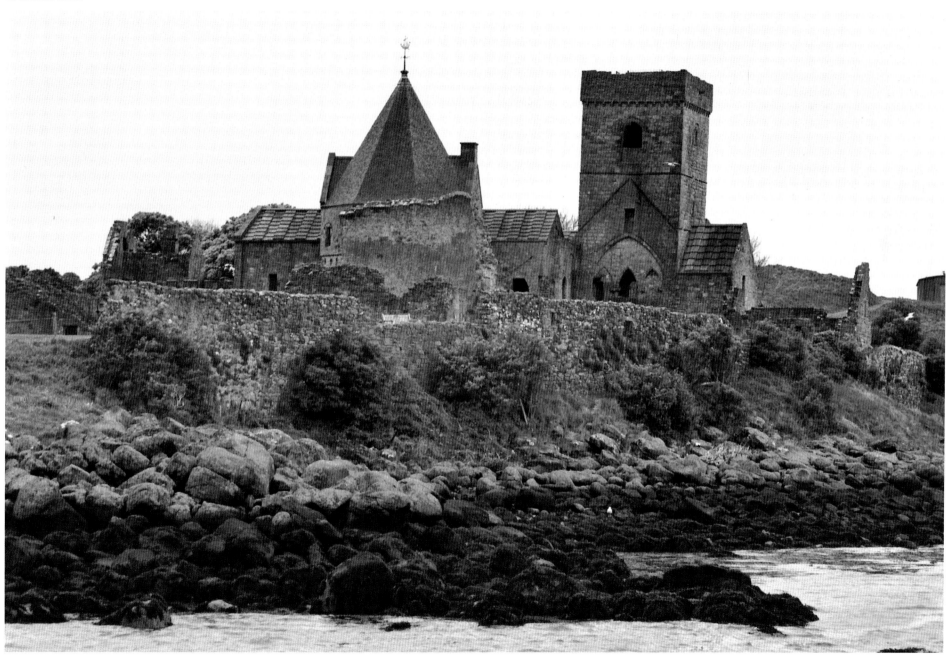

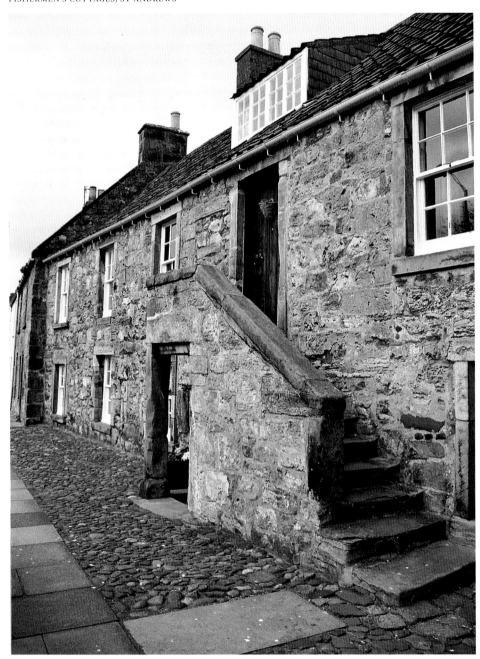

42

reduce a body to ashes and pyres for individual corpses must have consumed a great deal of valuable wood, almost certainly entire trees. Their lighting was likely the culmination of some ceremonial, perhaps processions in the manner of modern funeral corteges.

One question about this period has long troubled historians. Where are all the other bodies? Cremation and cist-burial were for the elite. How were the corpses of ordinary farmers disposed of? Were they placed in the sea? Were they left in wild places for predators to dismember and carry off? It is one of the greatest mysteries of our prehistory.

At the beginning of the 2nd millennium metal objects first made their way into the hands of the aristocracy in Fife. Copper and bronze daggers have been found in burials near Dunfermline and Methil and also jet beads, possibly from Whitby on the Yorkshire coast. Some hints of burial practice itself begin to come

to light. Deposits of pollen grains from meadowsweet have been found and they imply the presence of alcohol at an interment. The name is not related to grass pasture but derives from mead-sweet. Elsewhere in Scotland evidence of the use of flowers and vessels for food and drink, and in England the debris from huge wake-like feasts all seem to signal the beginning of some very long grave-side traditions.

The Bronze Age did not see a wholesale change from stone or bone to metal tools. For many centuries bronze and copper were the preserve of the wealthy and valued as much for appearance as any utility. Their existence in Fife is known almost exclusively through their discovery as grave-goods, the sort of expensive items the dead chose to take with them.

Whatever the structure of society in prehistoric Fife, it suffered a seismic shock at the end of the 2nd millennium. An Icelandic volcano, Hekla, blew itself to

smithereens in 1,159BC. The effect was cataclysmic. A tsunami smashed into the Atlantic coasts of Scotland and Ireland and probably funnelled into the Irish Sea and the North Sea. Millions of tonnes of ash and debris rocketed into the atmosphere and created a fatal sulphuric aerosol which occluded the sun for at least 18 years. A whole generation lived through a cycle of sunless summers. The shattered communities of the west faced stark choices. If they stayed, how could food be grown by the survivors? The sea, no doubt also affected, could sustain only a small remnant. It is likely that many fled the famine and the darkened skies, making their way east over the mountain passes.

None of this is recorded – only the eruption itself has been detected – but its effect must have changed radically how people lived their lives. After Hekla there is an impression of an increasingly fearful society, of many more weapons turning up in excavations, of

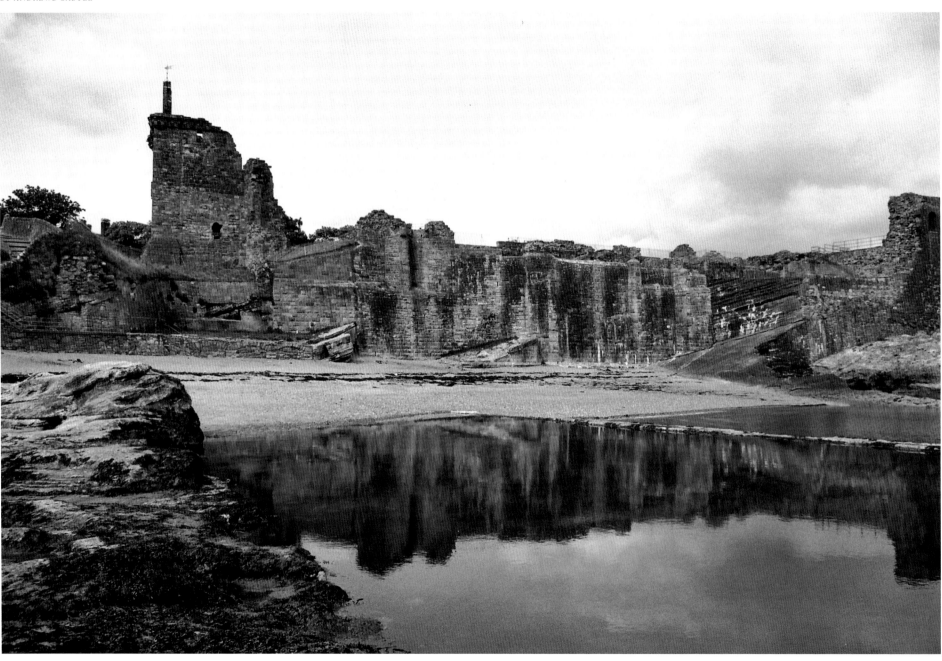

44

46

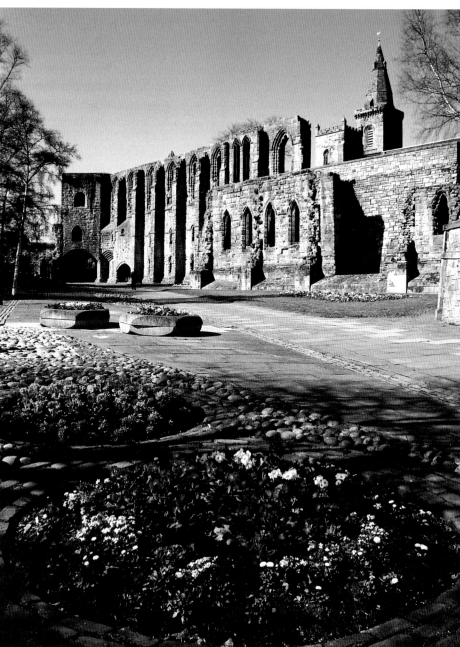

EDEN ESTUARY, GUARDBRIDGE

LEVEN VALLEY, LESLIE

50

KINCARDINE

NEWPORT ON TAY

defensive settlements, of the growth of a warrior elite. At Priestden Place in the southern suburbs of St Andrews a large cache of metal objects was discovered, dating to the early 1st millennium BC. Almost all of the large items are weapons; spear points, daggers and axes. Some may not have been used or were not intended for use, but even if they were only symbols, the symbolic weapons nevertheless represent a warlike society. Archaeologists have shown that several came from France and are a reminder that the prehistoric peoples did not live in entirely localised communities. And also that their leaders had become powerful and wealthy enough to encourage merchants to offer them such expensive goods.

When iron began to replace bronze in the 1st millennium BC, metal tools became cheaper and much more widespread, largely replacing stone and bone. It became possible to talk of an Iron Age and wisps of

evidence from elsewhere in Britain, Ireland and Europe combine to give a sense of the texture of that society. It almost certainly spoke a Celtic language. In Fife and over much of the rest of Scotland that Celtic language might be called Pictish.

No text or any aural tradition survives. No-one now can utter a sentence in Pictish, but tiny fragments can be found in personal names and place-names. The name Pict is itself instructive and refers to a long tradition of body decoration, specifically tattooing. And it may be that the distinctive designs found on much later Pictish symbols stones, the crescents, z-rods and a whole menagerie of animals, reflect that tradition of tattooing.

Recent scholarship has concluded that the Pictish language was Celtic, distantly related to modern Welsh and a cousin to modern Gaelic but it now exists only in echoes, and almost all are to be found on the map of

Fife. The prefix pit meant a parcel of land, perhaps even an estate and it is to be found in 78 place-names. Pitscottie, Pittencrieff, Pittenweem and many others were once farmed by people who spoke Pictish. And Kirkcaldy appears to be an entirely Pictish place-name. The first element has nothing to do with churches but comes from cair, meaning a fort and the second is related to caled for fierce. The latter may well be linked to an early name for the north of Scotland, Caledonia, the land of the fierce people. Or to apply a more macho gloss, a country of hard men.

Languages and their stages of development are extremely difficult to date with any accuracy, especially when no written record survives, but it is likely that the Pictish-speaking inhabitants of Fife of the early medieval period, around AD700 to AD1000, were the direct descendants of the prehistoric peoples of the 1st millennium BC. Place-names like Kirkcaldy and

52

Pittenweem may be amongst the oldest words used in daily speech.

The Romans wrote things down. The historian, Tacitus, recorded his father-in-law's campaign into northern Britain after AD79 in some detail, although he had maddeningly little to say about the native peoples. As Governor of the province of Britannia, Agricola mustered a substantial expeditionary force and led a well-planned invasion. Dividing his troops, he encircled hostile tribes such as the Selgovae in the Southern Uplands and avoided others who appeared to have been pacified by diplomacy. War was expensive and if promises and assurances could replace conflict, then the Romans almost always preferred that course. When Agricola's legions eventually reached the shores of the Forth, they chose to take the land route to the north through the Stirling Gap. The confederation of Pictish tribes who remained doggedly hostile retreated, almost certainly scorching the earth, removing or destroying any sources of food for the invaders as they went. Fife was bypassed and it seems very likely that a deal had been done. To the south of the Forth the Votadini of East Lothian and the Tweed Basin had avoided any incursion and probably profited handsomely from supplying the legionary quartermasters. The Kindred Hounds of Fife likely did the same. The pollen record of the period suggests open farmland and an ability to supply the Romans with much needed grain. Without it, Agricola's campaign would have ground to an ignominious halt.

At Bonnytown, near Boarhills in East Fife, a temporary camp built by a detachment of Agricola's invasion force has been discovered. Access to Fife was much easier by sea and it is almost certain that the Romans arrived at Boarhills by boat. Their purpose is less clear, perhaps it was simply a show of strength, a rapid means of achieving local cooperation – and at reasonable prices.

By the 2nd century AD the Greek geographer, Ptolemy, had drawn a map of Britain. In what is clearly the outline of Fife, he marked a place called Horrea, a word meaning granaries and also a river called Tina, almost certainly the River Eden. At Kinkell Cave near St Andrews and Constantine's Cave at Fife Ness, several Roman artefacts have come to light. Glass cups, shards of pottery and wine amphorae, they suggest high-status trade and regular contact with the powerful and glamorous world of the Roman Empire.

By contrast Scotland was not thought valuable: Roman commentators openly doubted the wisdom of spending resources and effort in conquering such an unproductive and chilly corner of northern Europe. But its subjection did have prestige attached – and in the political cauldron that was Rome, prestige mattered.

54

EDEN VALLEY, NEAR DAIRSIE

EDEN ESTUARY, FROM STRATHKINNESS

DEN OF LINDORES

COTTAGE NEAR FREUCHIE

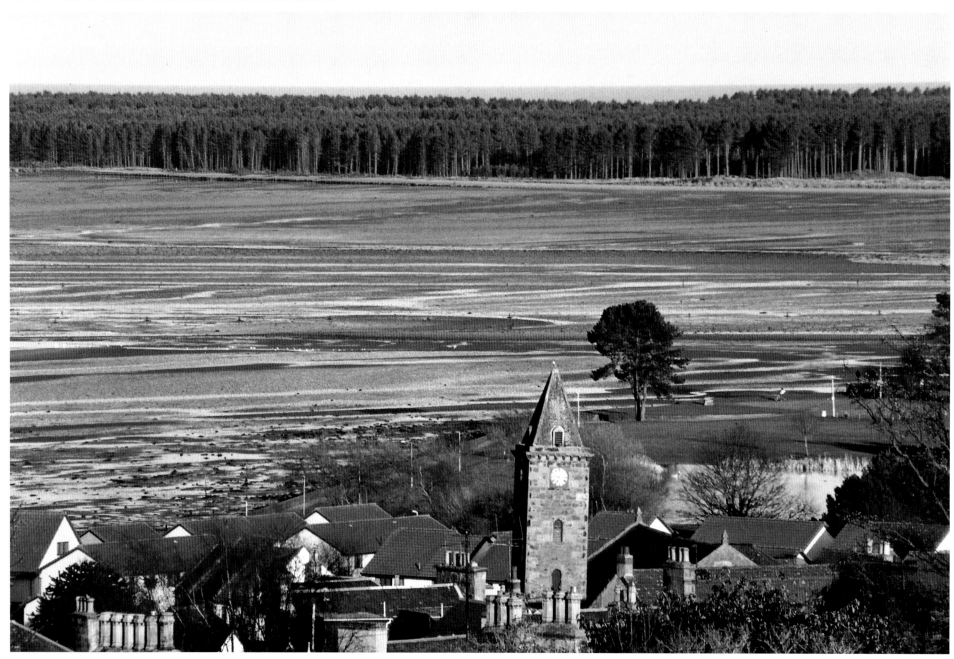

Scotland lay at the furthest limits of the world and if emperors could conquer it, then there was nowhere their power could not reach. Septimius Severus led his armies north, marching up Dere Street in AD210. A large force came by boat, sailing around the Fife coast to land at Carpow, on the shores of the Tay near Abernethy. Perhaps to extract a guarantee of regular supplies of grain, detachments were sent to build temporary camps at Auchtermuchty and at Edenwood.

Septimius died at York in 212 and his son, Caracalla, immediately withdrew from the north, suggesting that he had never supported his father's foray into such a worthless and dismal tract of territory. From that time forward, Fife lay outside the Empire but almost certainly inside its sphere of influence.

By the 4th century AD the centre of gravity of the Roman Empire had shifted decisively to the east, to the new city of Constantinople. And as barbarian armies pressed hard on its frontiers in the west, the mighty apparatus of state began to crumble. By the early 400s it was imploding, former provinces fragmenting as a succession of usurpers fought a series of vicious internecine wars. What remained of the Roman garrison abandoned Britain and the old Celtic kingdoms reasserted themselves. The Votadini became the Gododdin, their kings dominating the Lothians, the Tweed Basin – and perhaps Fife, the domain of the Kindred Hounds.

At the outset of the 5th century the native Celtic aristocracy appears to have been pagan, but by the end of the 6th they were all Christian, and in Fife there exists a fascinating memorial to the process of conversion. The Skeith Stone stands in its original position, next to a path which led to a sizeable enclosure near the village of Kilrenny in the East Neuk. Its faint outline may be all that remains of a very old monastic site, perhaps founded as early as the 5th century. The stone carries an incised cross inside a circle, what is sometimes known as a Maltese cross but most significant is an eroded, barely discernible mark in the top right hand corner. It is a chi rho symbol, an ancient example of Christian iconography.

As a persecuted sect, early Christians developed an understandable fondness for codes, means of recognising each other or places where they might be welcome. Chi and rho are two letters of the Greek alphabet and stand for the initial letters of Christ. This was not Jesus' name but a word which meant anointed. The Greek letters are written like an 'x' and an 'r' with the latter looking more like a capital 'p'. Combined, with the shaft of the rho bisecting the crossing of the chi, these symbols are found in several places in Galloway closely associated with Scotland's first Christian missionary, St Ninian. And also at Kilrenny. Explanation – very unusually for the

period – comes from a written source. When the great 8th century historian, Bede of Jarrow, awards a passing mention to Ninian, he states that he converted the Southern Picts who live on this side of the mountains. It looks very much as though Kilrenny was a missionary church set up from Galloway and that Fife was known as Southern Pictland, or at least a part of it.

Almost all that is understood about the later Picts comes from readings of their carved stones, their symbol stones. Hundreds have survived and some still stand in Fife. The earliest carvings appear to have been made on the living rock and very impressive examples can be seen at the Wemyss Caves. Some are obvious, such as swords, mirrors and combs, while others are obscure. It may be that they all represent stylised sacrifices of metal objects, the sort of objects broken and then deposited in wet places by the prehistoric peoples. It is impossible to be sure.

By the 6th century the symbol stones were carrying carvings of Christian crosses and also more naturalistic scenes. On stones from Largo and Scoonie the Pictish aristocracy are glimpsed indulging in a favourite pastime. On horseback with hounds running ahead, they are hunting deer.

By the 7th century St Andrews was developing as an important religious focus. At Hallow Hill, now in the southern suburbs of the town, a very large Christian cemetery has been excavated, more than 130 east-west oriented graves surviving out of as many as 400 or 500 original burials. Associated with the site is a significant lost place-name. Hallow Hill was once known as Eglesnamin, the Church of the Saint. The first element ultimately derives from the Latin, ecclesia, and it denotes the site of a very early church. There are four other eccles names in Fife. The church at Hallow Hill may be too early to be associated with St Andrew – and also in

the wrong place but the Pictish settlement known as Kinrimond, meaning at the head of the King's Moor was growing in importance. An early monastery had been founded, probably at the extreme end of the headland, beyond the cathedral precincts on the height called Kirk Hill, and it was sufficiently notable to be recorded in Irish annals. In the year 747, wrote the scribes, Tuathalan, the Abbot of Kinrimond, died.

Around the same time a stunning, virtuoso piece of Pictish sculpture was commissioned and executed at Kinrimond. What is now known as the St Andrews Sarcophagus is one of the great artistic achievements of early medieval Europe, and it was probably paid for by a Pictish king. Oengus, son of Fergus, may have intended it for himself. If so, then it may mean that the royal monastery at Kinrimond was considered the premier church in Southern Pictland. Why that should be so – particularly since the political focus lay further west in

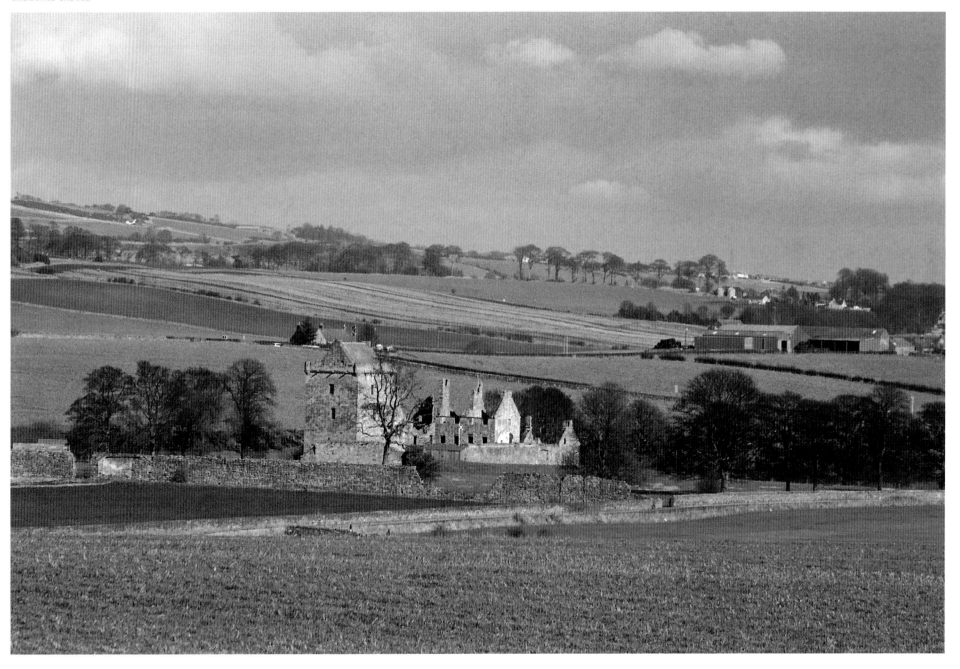

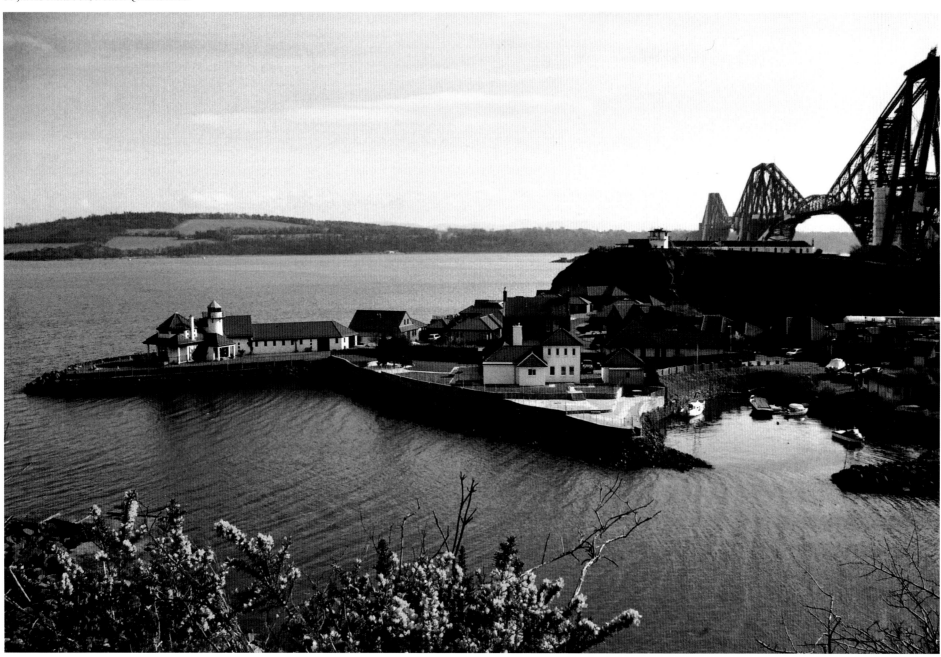

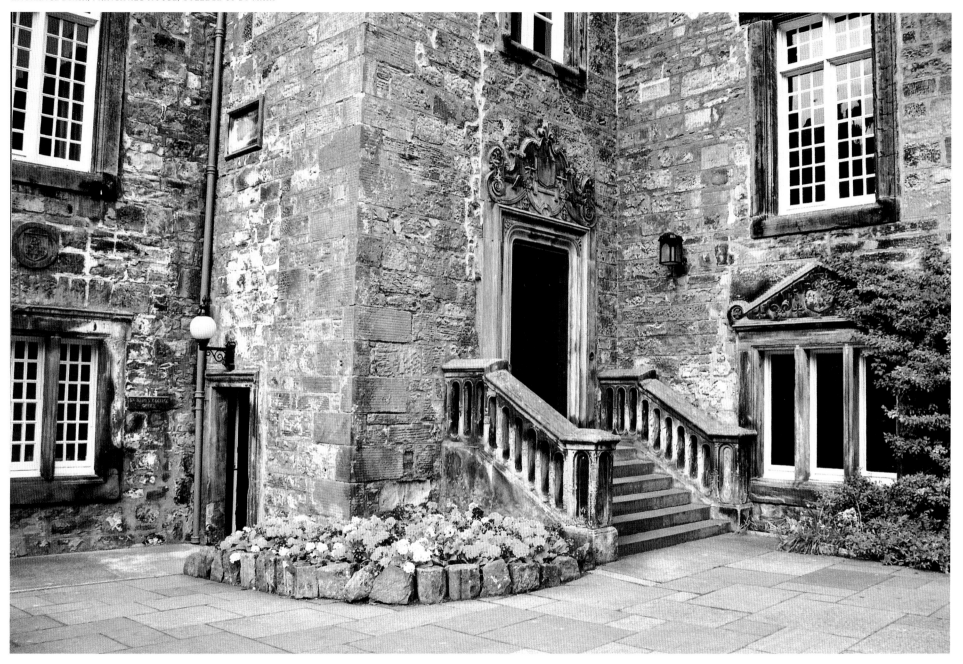

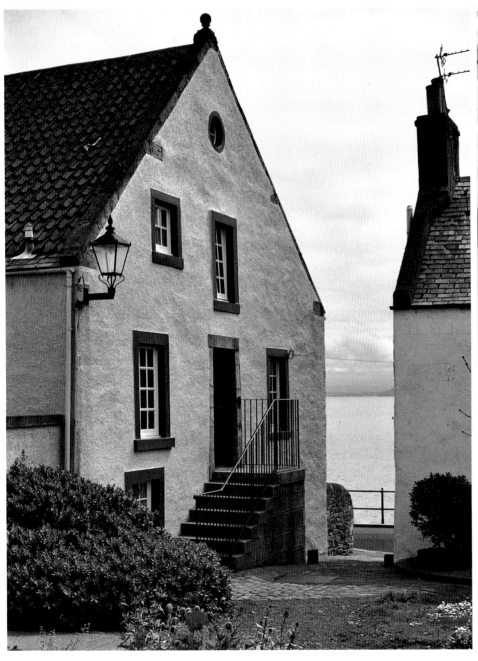

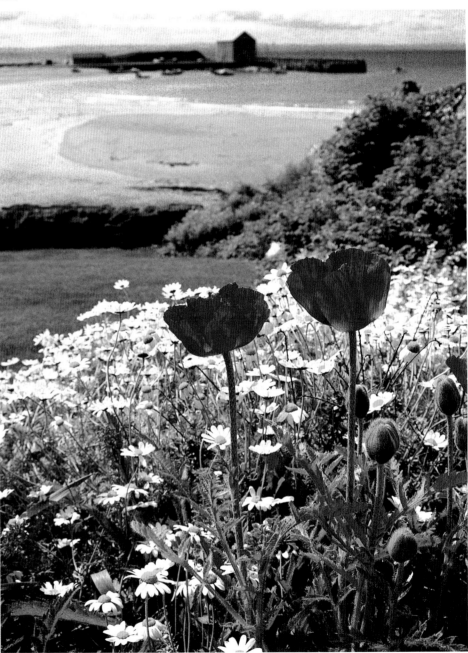

Strathearn – is difficult to understand. Perhaps the relics of St Andrew had come to Kinrimond by the middle of the 8th century. He was the brother of St Peter, the rock of the Church, and a shrine containing his bones would have attracted immense prestige and drawn many thousands of pilgrims. Perhaps the sarcophagus was intended as a reliquary, a resting place for the bones of a saint.

Oengus I ruled over Southern Pictland for a long time, from 729 to 761. Interestingly his name is not Pictish but Gaelic, and he had strong ancestral links to the kingdom of Argyll, often called Dalriada. The 8th century saw the Gaelic kings of the west become more and more powerful in the east. There is a sense of an aristocracy on the move, its influence reaching far into Pictland, almost certainly as far as Kinrimond. By 789 Constantine I, the son of Fergus, was king in the east and twenty years later, he is listed as King of Argyll.

Gaelic place-names plot this takeover – although the dates of their coining are hard to fix, nevertheless it appears that from 900 to 1200 many came into use. There are 108 in Fife. One of the most common is baile, meaning an estate or a farm, and it is generally rendered as the prefix Bal. Balcomie in the East Neuk combines it with a personal name, as does Balmalcolm near Kingskettle. Just a mile along the road from Pitlessie, it reflects the chequered texture of Fife's early Celtic society.

In 793 the Vikings sailed into history. That year they attacked the monastery of St Cuthbert at Lindisfarne and for the next two generations, their sea-lords terrorised British and Irish coastlines. Where rivers were wide and navigable, they also struck inland, and in 839 dealt a fatal blow to the Pictish kingdom. At the Battle of Strathearn, Constantine's brother, Oengus II, was killed along with his sons, many noblemen and

their warbands. The political vacuum was eventually filled by the Argyll kings, by Kenneth MacAlpin, the king from whom all Scots kings are numbered and who established some stability in the east. By 906 the Gaelic takeover seemed complete when Constantine II climbed the Hill of Faith at Scone with his Bishop of St Andrews, Cellach. They declared that the customs of the Scots (meaning the Gaelic-speakers of the west) were paramount, that the name of their nation was Alba, still the Gaelic name for Scotland, and in so doing they consigned the ancient Pictish kingdom to history.

The dialects of Old Welsh spoken in Fife and elsewhere in Scotland probably took a good deal longer to wither. In the Southern Uplands the old language may have lingered in the remote hill communities until the 13th century, but in Fife, where communication has always been good and few enclaves are truly remote, it is likely that Gaelic, the language of royal power,

established itself more quickly. Early versions of English were certainly spoken on the southern shores of the Forth in the medieval period, and it may be that it made the short sea crossing to Fife at about the same time.

Whichever language was preferred, society remained firmly Celtic in the 10th century and on into the 11th. The year turned around the four festivals of Imbolc in February, Beltane in May, Lughnasa in August and Samhuinn in October. These were Christianised into quarter-days with saints attached but at St Andrews and Inverkeithing the Lughnasa or Lammas Fair stubbornly survived. Irish or Celtic Christianity also set the spiritual tone in Fife. The early monks greatly admired a group of middle eastern hermits known as the Desert Fathers. To escape the persecution of the towns during the late Roman Empire, these men fled into the desert to lead hard, ascetic lives devoted to prayer and contemplation. They preferred lonely,

isolated places such as caves or hidden valleys. Their hermitages were imitated in Ireland, but in the absence of sandy deserts, the sea and windswept seaside places were thought of as substitutes. Perhaps the most spectacular of the very early Irish monasteries is perched on the rocky Atlantic island known as Skellig Michael. The Irish word for such a hermitage was a diseart, and it is remembered in the Fife place-name of Dysart where there is a seaside cave associated with St Serf. There were also early monastic communities on the Isle of May, and the position of St Andrews on a rocky promontary jutting out into the sea might have been attractive for exactly that reason.

Like the foundations at Glendalough in the Wicklow Mountains or Armagh, Kildare and Clonmacnoise (on an island in the Shannon), St Andrews appears to have grown into a monastic town. In a precinct adjacent to the Pictish royal palace, there seem to have been seven

churches or chapels and the tall spire of St Rule is very reminiscent of the towers in the Irish monasteries. Known as the Culdees, derived from Celi De or the Companions of God, the monks who said mass in the churches of St Andrews followed an Irish rule and had close links with the Columban communities of the west.

The relics of St Andrew had made the monastery pre-eminent. Only one other site, at Santiago de Compostela in northern Spain, could boast the bones of a martyred apostle of Christ. Apparently the Culdees' treasure consisted of a tooth, a kneecap, three fingers of the right hand and an arm bone and because they represented a real and tangible link with the Son of God, the bones attracted many thousands of pilgrims to Fife. It was believed that the relics literally exuded sanctity, that closeness to the reliquary could expunge sin, that the pilgrimage itself made the passage to Heaven much easier. Every summer they came, bands of

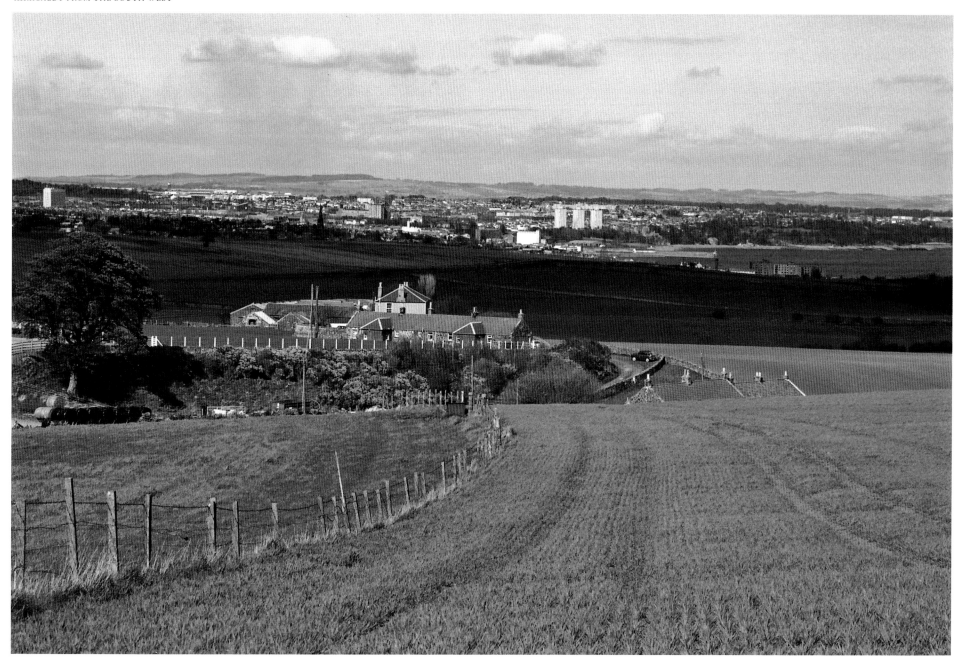

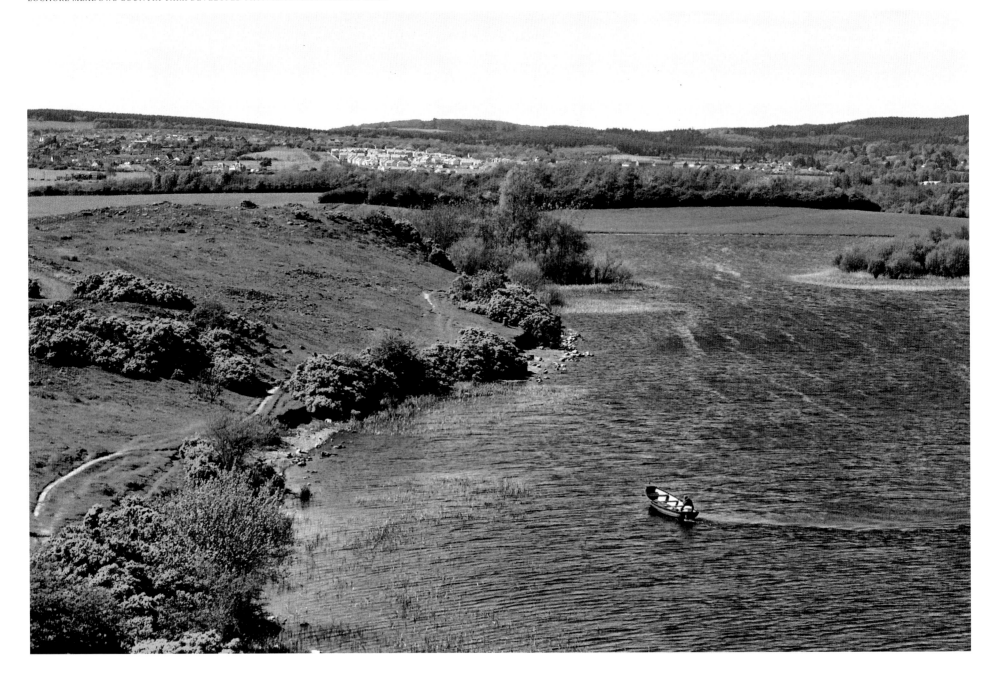

pilgrims seeking salvation. It was not tourism, but its effect on the Fife economy must have been similar. At least five routes led people to St Andrews and many places, like the healing well at Scotlandwell, flourished as trade passed through – in both directions.

Other shrines became part of the sacred itinerary. In the shadowy shape of Ethernan, the Isle of May developed the cult of its own Celtic saint. Many early Christian burials have been found near Ethernan's shrine, and a remarkable skeleton came to light during a recent excavation. Archaeologists could tell that the young man had been a pilgrim, and also where he had been on pilgrimage. Shoved into his mouth was half of a scallop shell, the emblem of St James, and a sign that the man had visited his church at Compostela in Spain. Here he was at the shrine of St Ethernan, perhaps on his way to or having been at St Andrews. It looks as though he had managed the extraordinary feat of

travelling to both of the major places of pilgrimage in western Europe.

In 1070 Malcolm III Canmore married an English princess. Margaret and her family had fled from the Norman invasion and found sanctuary in Scotland. Queen Margaret was devout and to help pilgrims reach St Andrews more easily, she established the Queen's Ferry across the Firth of Forth. Passage was free and much used.

The Gaelic kings of Scotland had built a castle and residence at Dunfermline (the scant remains in Pittencrieff Park may show where it stood) and in the same year as she became queen, Margaret founded a community of Benedictine monks nearby. Sent north from Canterbury, these men were part of a reformed order, with European and papal connections, and followed a rule different from the hermetic Irish traditions of the Culdees. Margaret had been born in

Hungary and raised in England. With her arrival at the Scottish court, she brought new ideas, and never mastering the Gaelic spoken by her husband and his family, also helped introduce the English language.

Margaret's confessor, the English monk, Turgot, wrote a life of his queen soon after her death. And as often happened, it sowed the seeds of her saintly reputation. By 1250 Queen Margaret had become St Margaret and her shrine at Dunfermline Abbey attracted many pilgrims. When her bones were translated from her coffin into a new reliquary, it was claimed that a sweet smell filled the church, what was understood to be the odour of sanctity. Along with other relics, Margaret's shirt was put on show and physical contact with it was thought to have near-magical powers. Several Scottish queens sent for the shirt when they were close to giving birth. Their certain hope was that wearing it would ease the pains of labour

BUDDO ROCK

RIPE WHEATFIELD, BOARHILLS

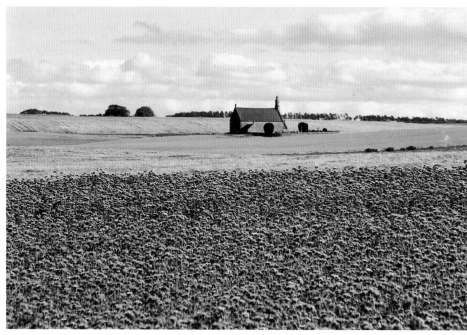

BOARHILLS CHURCH AND PHACELIA FIELD

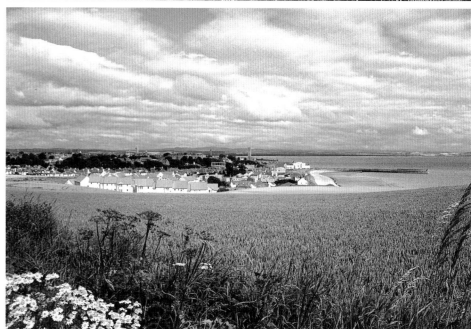

ST ANDREWS

and help deliver a royal child safely. Whatever the efficacy of St Margaret's shirt, three Scottish kings were born at Dunfermline: David I, James I and Charles I. And because of the glow of her sanctity and the prestige it conferred on the abbey, the bodies of Scottish kings were regularly brought to Dunfermline for burial. Seven kings, four queens, five princes and two princesses have their memorials in the abbey and two of the greatest were interred near the high altar: David I and Robert I.

In 1072 Malcolm III Canmore made a wise decision. At Abernethy, on the north-western borders of Fife, he submitted to one of medieval Europe's greatest warriors, the man known to contemporaries as William the Bastard and, more decorously, to generations of schoolchildren as William the Conqueror. In practical terms the submission appeared to mean very little. Canmore continued to have ambitions in England and during a foray into Northumberland in 1093 both he and his eldest son, Edward, were killed. Soon afterwards his saintly queen followed him and both were buried at Dunfermline.

At the centre of the medieval kingdom, with royal churches at its eastern and western extremities, covered by rich agricultural land and possessing useful natural resources, Fife was a jewel in the monarch's crown. The earldom of Fife first comes on record in 1095 when Constantine, a prince in the house of Canmore, held it. It seems that succeeding kings saw Fife as a quasi-royal province with the earldom reserved for younger children not likely to ascend the throne. Over time there grew up an important customary role. The Earls of Fife were seen as kingmakers, that is, entitled to lead the king-designate to his throne and to his crowning. In 1306 Isabel, Countess of Fife, crowned Robert the Bruce at Scone Abbey, and her ancient role swept aside many objections to the legitimacy of the ceremony.

One of Scotland's very greatest kings, David I, decided to develop the Fife economy. As with the Border abbeys, he used the church as his agent in the process. Refounding Dunfermline Abbey and endowing it with lavish gifts of land, services and priviliges, he encouraged the monks to exploit their European connections to foster trade. Between 1124 and 1127 Dunfermline became one of Scotland's very earliest burghs. Many others were established, and at Inverkeithing, Kinghorn, Kirkcaldy and Crail, a clear intention was to provide port-burghs facing east, towards the mouth of the Forth and the North Sea beyond. Even though surviving harbours such as Crail now seem very small, able to berth only a few fishing boats, it should be borne in mind that medieval merchant ships were not large.

Trade and markets were the prime business of the new burghs. Most were strung out on either side of a single street, and often it widened to accommodate stalls

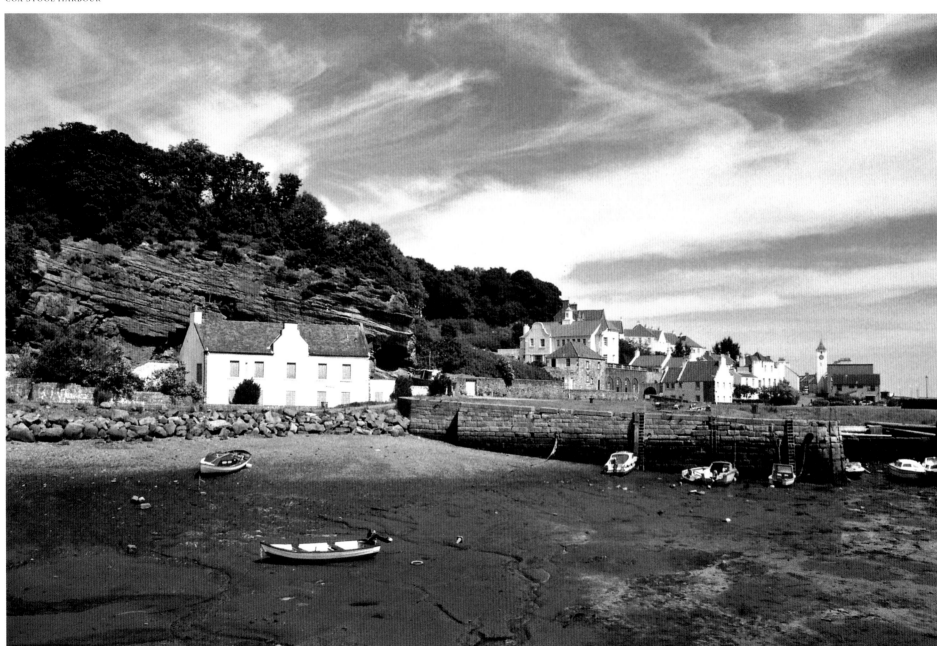

on market days. Kirkcaldy's still retains its medieval shape. Set on a raised beach, about 10 metres above sea level, the layout of the High Street is much influenced by geography. The streetline is sinuous, like the original feature it stands on. The ground rises steeply behind and the backlands of the northern properties are often terraced.

Burghs did not grow randomly at first. Evidence exists of liners, surveyors who set out the burgh properties, or burgages, with stakes hammered into the virgin ground and lines drawn tight between them to mark off the building plots. At St Andrews a man known as Mainard the Fleming was expert in this and he created a town plan which is still discernible, especially in South Street. The lanes or vennels in these old burghs are a sure sign of their antiquity. As commerce developed and more and more people came to settle in the burgh, the backlands became built up,

usually as the homes of poorer people. In order to gain access through the forelands to the streets, a vennel was needed and many survive in the Fife towns.

The street plan of St Andrews was designed for trade, but also adapted to meet slightly different purposes. In 1160 work began on a huge, grand church, a cathedral fit to house the shrine of Scotland's greatest saint. Planned as the largest medieval building north of Durham, it would be a focus which almost overwhelmed the burgh and its creation demanded that the street plan be surbordinated to its size and status.

Throughout the year, but most importantly on the saint's feast day of 30th November, St Andrews was the stage for elaborate religious processions. North Street was designed to lead up to the main west door of the cathedral, and to allow a long and uninterrupted vista of the richly painted facade above the door. Straight and wide, it could show the impressive scale and sweep of

important processions. Medieval sources describe them. Scores of priests and monks, altar boys holding candles, thurifers swinging censers of incense, acolytes holding beautifully bound and jewelled bibles, choirs singing, and on 30th November each year a group of priests carrying the relics of St Andrew himself, a procession walking slowly up North Street to the great church would have had the desired awe-inspiring effect. Some historians believe that South Street was set out in such a way as to link it to North Street so that processions could walk in a circle around the town and not disturb the important market in Market Street. The latter is much more narrow, does not lead to the cathedral and simply fizzles out in a network of lanes and vennels.

While bishops and kings walked the streets of St Andrews, the Earls of Fife held the middle of the kingdom. Based at Cupar, their estates included both agricultural and tracts of wild land. In common with, it

seems, almost every medieval aristocratic family in Britain, the Earls of Fife were very enthusiastic huntsmen. Their passion moved them from Cupar to the lodge at Falkland, the centre of happy hunting country and ultimately the impulse for the creation of the palace and the small burgh around it. After Falkland had come into royal ownership, James IV had what amounted to a royal palace built. James V converted it in a renaissance style, and to the delight of a small but devoted cadre of players also had a real tennis court made – which survives and is still played in. In the 19th century the Marquis of Bute had Falkland Palace carefully restored and it is now cared for by the National Trust for Scotland.

During the medieval period, when the Earls of Fife were still at Falkland, kings ran their hounds further to the east and owned a large area of forest (not so much a wooded area as wild land) known as the Cursus Apri Regalis, the Run of the Royal Boar. This stretched from the southern suburbs of St Andrews to a place whose name remembers it, Boarhills, and then it turned west towards Kemback and Cupar.

Royal patronage in Fife took other forms. After King David II was badly injured by an arrow in the face at the Battle of Neville's Cross in 1346, he found himself in captivity, ransomed by the English for the staggering sum of 100,000 marks. His wound never healed properly and on advice the king came to the shrine of the ancient Irish saint, Moinenn, at the village of Inverie on the Fife coast. His prayers appear to have been answered and David caused the magnificent parish church to be built in grateful thanks and the village to be renamed after the old saint. Over the centuries St Monans retained its religious resonances and it was home to evangelical sects such as the Open and Close Brethren.

The hard and dangerous lives of fishermen partly drove them to worship a hard and unyielding God, perhaps making their lives all of a piece, certainly forming part of a tradition also exemplified on the southern coasts of the Moray Firth. Further to the east, in the coal towns and villages of Fife, communities were similarly forced together by the equally dangerous business of mining – and from an early period.

The monks of Dunfermline Abbey sought permission to dig coal on their land at Pittencrieff as early as 1291, but there is no doubt that it was used for fuel long before. The first diggings were at coal-heughs, places where the seams had broken through the topsoil and were easy to get at. The monks probably used coal to heat their draughty church but in general wood was preferred for cooking. Many people believed that coal gave off noxious fumes which spoiled food. The most common use was to make salt. Brine-rich water often accompanies deposits of coal and on both sides of the

Forth, it was poured into broad, iron saltpans and with blazing fires underneath, boiled off until only the sea-salt was left. Dysart was known as the Saut Toon and the fires blazed at Pan Ha', a stretch of sea-side haughland where both the briny water and the coal could be conveniently brought together. In the medieval period there was a huge demand for salt as a preservative for meat, and in the 1490s Dysart exported more than 70% of Scotland's total output. Because of its trade in salt to the Netherlands, the town was also called Little Holland.

Coal mining became more dangerous as miners were forced to delve deeper. When the coal-heughs were worked out, bell-pits were sunk. So called because of their shape, these were simple shafts dug down to a seam and then mined laterally on both sides. Men hacked out lumps of coal (always trying to avoid breaking up large pieces – they fetched a much better price than dross) and women and children filled baskets behind them while others pulled them to the surface with simple winches. Flooding and collapse were major dangers, but such was the scale of the Fife coalfield that another bell-pit could be quickly started when others became unworkable.

While the church was stimulating industry in west Fife, entirely different initiatives were stirring in the east. In 1410 St Andrews University is first mentioned, and by 1412 it was formally founded by Bishop Henry Wardlaw when he received papal confirmation. As the Great Schism of 1378 produced two popes, one in Rome and another in Avignon, Scotland's prelates pledged their loyalty to the latter. This meant that Scottish students were banned from most of Europe's universities, who had remained faithful to the Roman pope. The radical and creative solution was to found a university in Scotland.

The impetus appears to have been nationalistic as well as academic. If Scotland was to maintain an independent church, then it should have a university to train its own theologians and priests. And it was also a matter of prestige. By the early 15th century more than 50 universities had been founded in most corners of Europe, and where could be more appropriate for Scotland's than the home of the relics of the nation's patron saint? Kirkcaldy, Dysart and Dunfermline grew because they had coal and people needed salt, while St Andrews had no natural resources to commend it. Only the bones of one of Christ's apostles, and the immense power of faith drove the town and the cathedral to their windy pre-eminence.

Through the 15th and early 16th centuries the new university acquired colleges: St Salvator's in 1450, St Leonard's in 1512 and St Mary's in 1538. It was essentially a seminary dedicated to and controlled by the church.

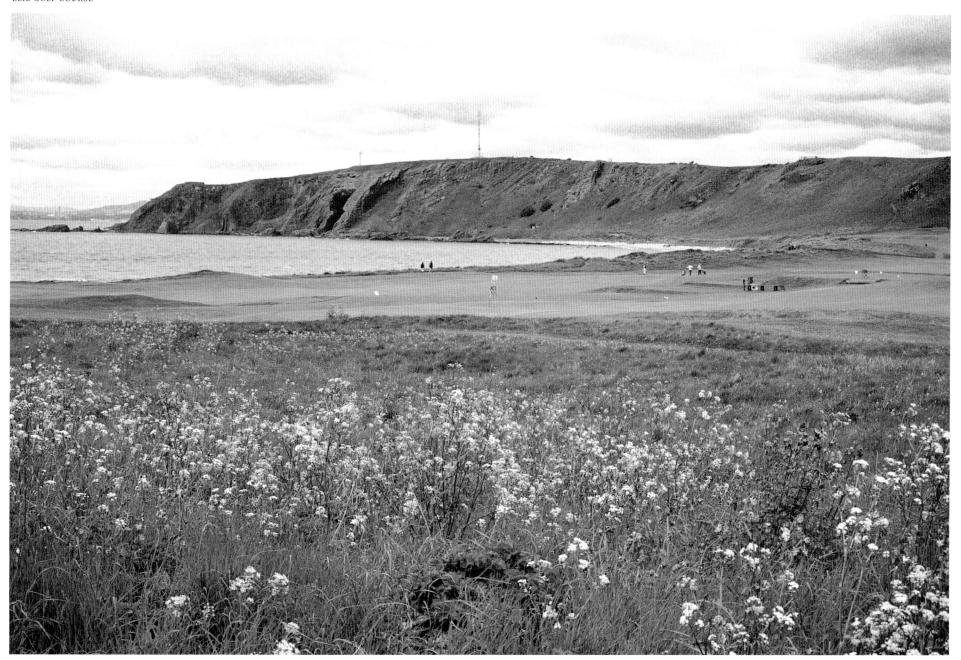

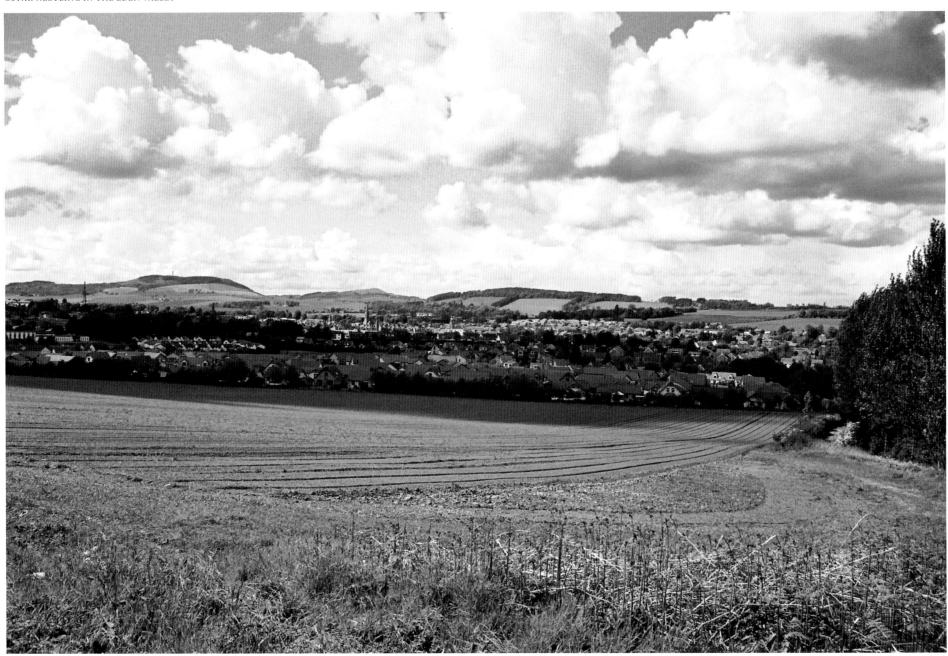

After the Scottish Reformation took hold in the 1560s, St Andrews prospered – surprisingly. Former church lands were gifted to the university and its academic nature changed, broadening considerably beyond the purely religious. Graduates included George Buchanan, the historian, John Napier, scientist and inventor, James (the Admirable) Crichton, the poet, and two famous soldiers, James, Marquis of Montrose and John, Viscount Dundee.

As the ecclesiastical capital of Scotland, St Andrews saw many of the turning moments of the Reformation. Martyrs were led to their pyres in the streets of the town, the castle beseiged and notable churchmen murdered. On the cobbles outside St Salvator's Chapel in North Street the letters PH are picked out. This was the site of a literally incendiary incident which helped to spark the movement for reform in Scotland's church. Patrick Hamilton was a believer in the teachings of Martin Luther, and when he returned from Europe to St Andrews in 1527, it seemed only a matter of time before he clashed with the authorities. It turned out to be a fatal clash and his burning at the stake galvanised Scotland's reformers.

Almost twenty years later the protestant preacher, George Wishart, was strangled in the dungeons of St Andrews Castle and his body burnt at the stake outside the gateway. Cardinal David Beaton is said to have watched from a window. Three months later a party of Fife lairds attacked and assassinated him, and the conspirators took refuge in St Andrews Castle. John Knox was amongst them, and after a fourteen month seige, he and his comrades were captured by a French force and sent either to imprisonment in France, or like Knox, to suffer the brutal punishment of becoming a galley slave.

On 28th April 1558 a stake was erected outside the northern walls of St Andrews Cathedral. An old and harmless protestant schoolmaster called Walter Myln was tied to it and the brushwood and logs around his feet lit. It was a callous and unnecessary act, the creation of a martyr whose death moved the increasingly protestant nobility to act decisively.

John Knox returned from captivity, landed at Anstruther, and with the support of Lord James Stewart and the Earl of Argyll, he began to whip up reforming fervour in Fife. After his sermons, sacred sculpture in the churches at Crail and Anstruther was smashed and the altars removed. At Holy Trinity in St Andrews, Knox exhorted the congregation to cleanse their kirk of popish images, and then over the next few fevered days, the cathedral was attacked and the Franciscan and Dominican churches destroyed (nothing but a blackened fragment remains of the latter in South Street). Particularly poignant was the wrecking of the

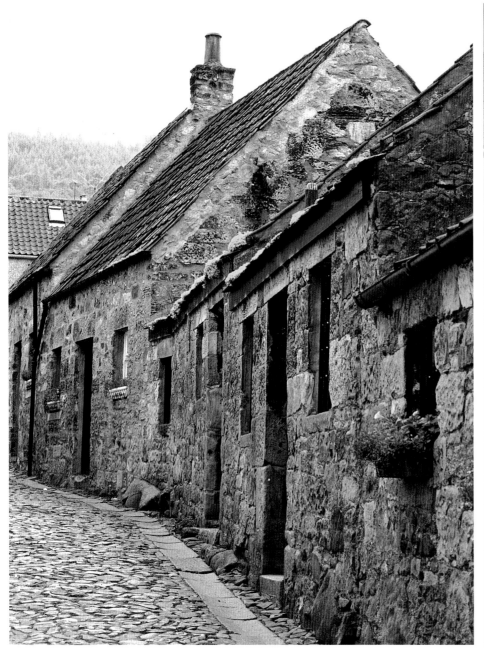

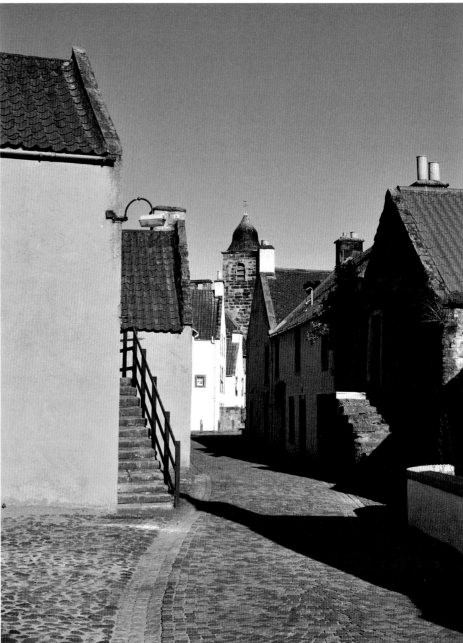

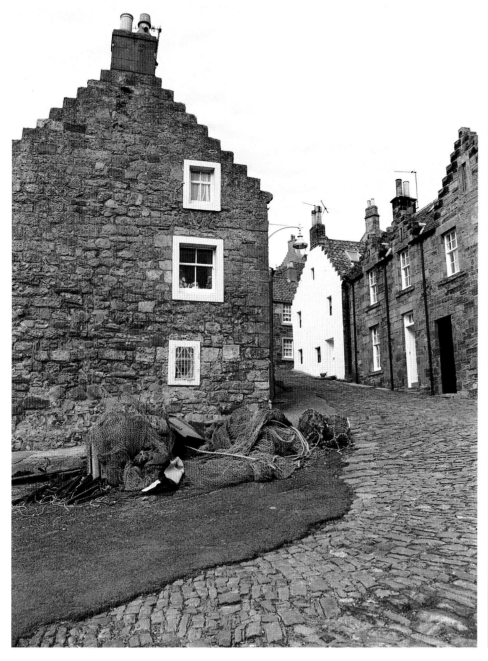

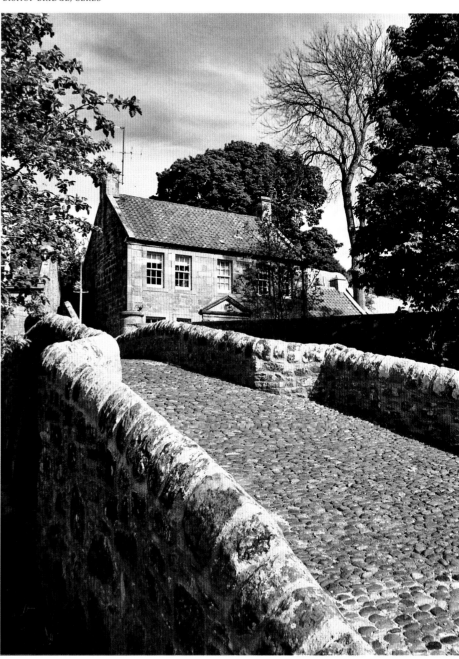

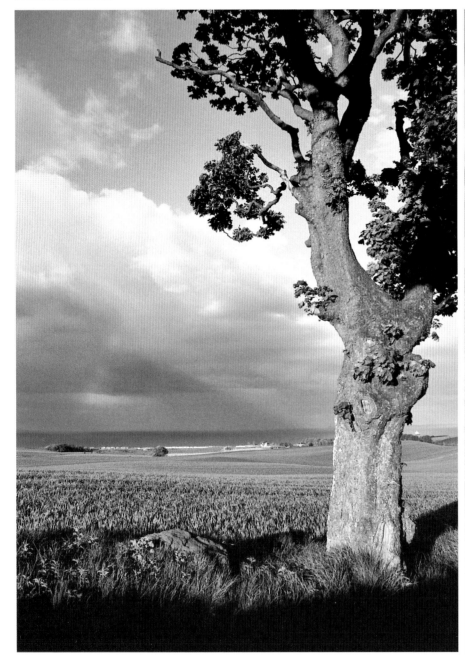

ancient church of St Mary of the Rock, perhaps the first to be built at St Andrews. With the coming of the Reformation, the town gradually lost its pre-eminence as the ecclesiastical focus of Scotland. When the protestant nobility, the Lords of the Congregation, convened a parliament which, in essence, converted Scotland to the reformed faith, it was held in Edinburgh.

For several generations the Scottish Reformation evolved, and by the end of the 17th century was more or less complete. Its impact on Fife was profound. The church and its vast wealth was dismantled and replaced by a new organisation, what became the Church of Scotland. Fife faced even more disruption than other parts of Scotland. Pilgrimage was discouraged by the reformers and then banned. The cult of saints and their relics met a similar, often violent, fate. The Fife economy immediately suffered. The loss of the lucrative pilgrim trade affected the whole of the kingdom, not just

Dunfermline and St Andrews, and the annual injection of revenue simply ceased. Not until the 19th century did East Fife recover.

During the late 16th and 17th centuries the new church developed the idea of a godly commonwealth. Communities aspired to draw ever closer to God, and part of that process involved purification. In what became a form of fatal hysteria, parishes began to suspect women in particular of practising witchcraft. Scotland as a whole became obsessed with the notion that some of its people were in communion with the Devil and, to preserve the godly commonwealth, these foul pollutants had to be found and rooted out. In a long series of so-called witch trials, thousands of people were subjected to farragos of justice, underwent horrific torture and often met an appalling fate when they were burned at the stake.

As a religious focus, St Andrews was often the

venue for these trials and executions. Many suspected witches were held in the castle, where they were tortured, and once some sort of specious proof or confession had been extracted, usually led or dragged to the stake near the main gate. The luckier were strangled before the fires were lit, others suffered unimaginable agonies when they were burned alive, or 'quick'. These grisly rituals gave rise to the phrase the quick and the dead. Fishing communities seemed prone to sustained bouts of witch-hunting, and at Pittenweem, trials were still going on as late as 1704. A chilling stanza of folk poetry from the time recalls the drowning of a convicted consort of the Devil in Kilconquhar Loch.

They tied her arms behind her back
And twisted them wi' a pin
And they dragged her to Kilconquhar Loch
And coupit the limmer in.

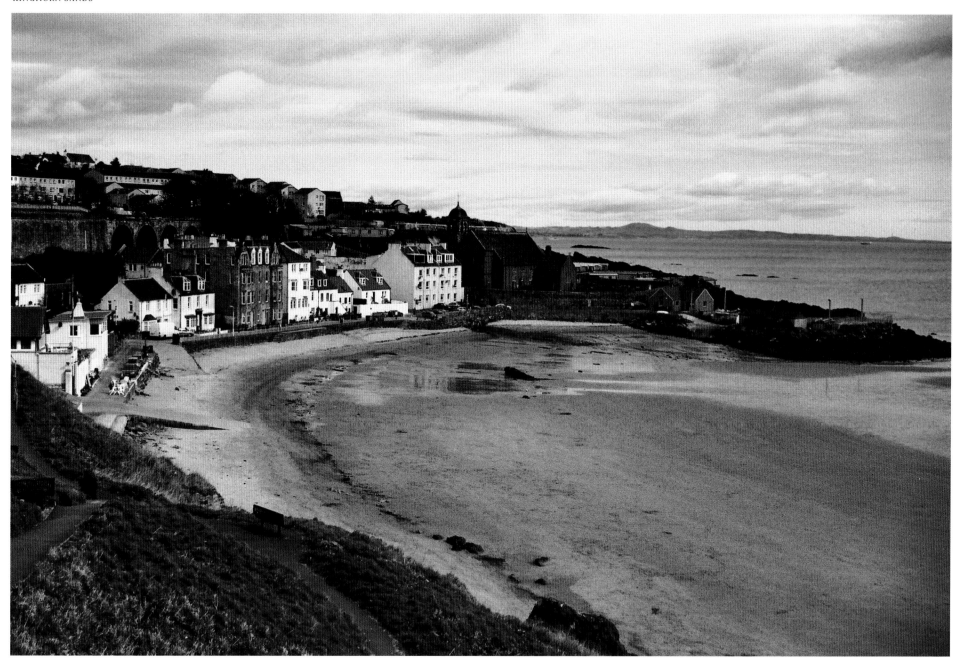

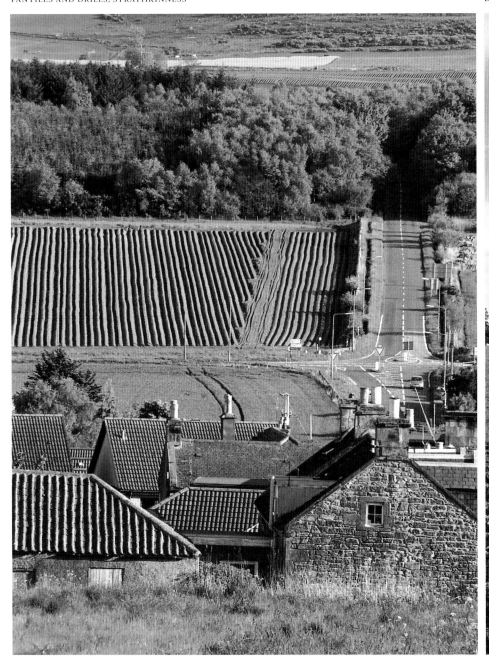

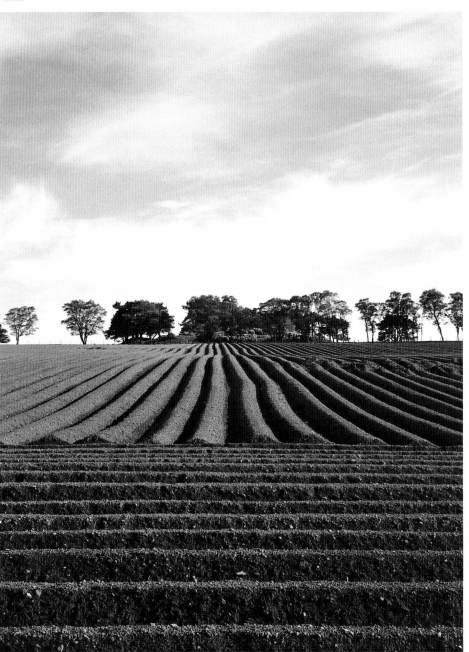

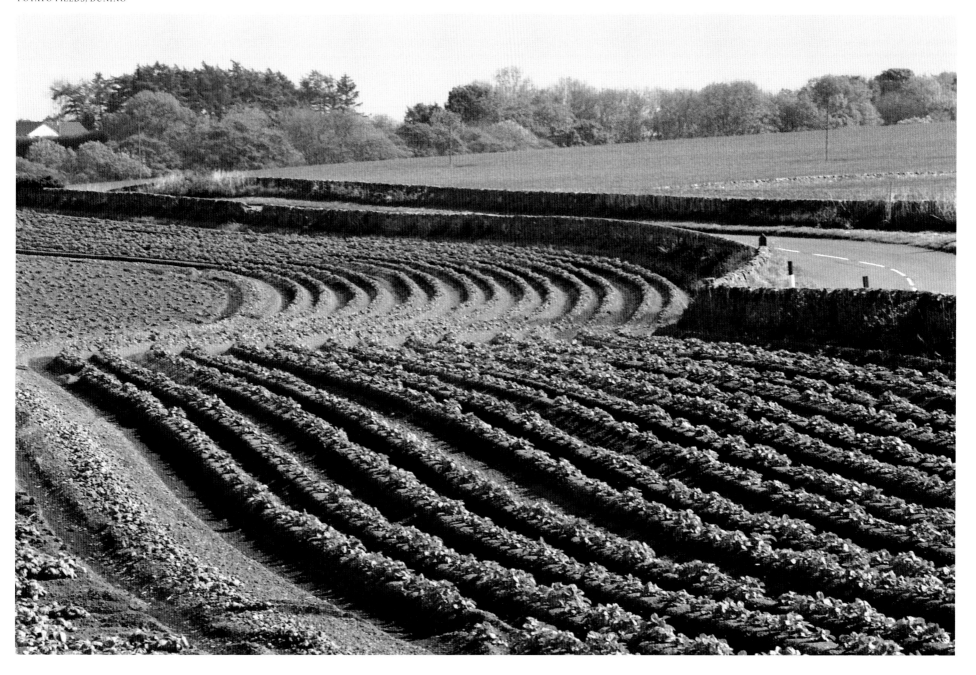

It was an obscene episode, one which casts a dark shadow over Fife's history.

Because the voices of ordinary people in Scotland (and elsewhere) are rarely heard by history much before the late 19th century, it is difficult to trace the pace of reform in the church. It looks as though the church changed from the top down, while farm labourers, coal-diggers and other sons of the soil probably retained the essence of the old catholic faith for at least a generation.

In any case, John Knox and the other zealots needed the support of the aristocracy and where it was forthcoming, change followed fast. And in Fife it seemed faster. Andrew Melville, the Principal of St Mary's College at St Andrews University in the 1580s and 1590s, preached radical ideas and one of them became very influential. Christ's Kingdom of Scotland was the concept which characterised Melville's vision for not only the Church of Scotland but the entire country. The

state was separate, ruled by the king, but the church was autonomous, ruled by its General Assembly, and both were subject to God alone. Famously, Melville told King James VI at Falkland that he was nothing but God's silly vassal. Not surprisingly these views were deeply unpopular at court, and Melville found himself imprisoned in the Tower of London, ultimately dying in exile. But some historians see him as the true founder of the presbyterian church, more influential than Knox.

The redistribution of church wealth, and especially church lands, altered the social map of Scotland and of Fife. New names, often royal servants, were rewarded with these spoils of the Reformation. In the 17th century the Leslies became prominent. After fighting in Europe for the protestant forces of the Swedish King Gustavus Adolphus, Alexander Leslie became involved with the civil war in Britain. Elevated to the earldom of Leven, he built himself a castle at Balgonie. No relation, but

following a very similar career path, David Leslie also had castle-building ambitions and his dramatic conversion of Newark, near St Monans, still totters unsteadily on the edge of the sea-cliffs. George Leslie, still no relation, found himself finally on the right side during the dynastic convulsions of the 17th century and as Lord Melville, he built the grand Melville House on the old estate at Monimail, formerly the property of the Bishops of St Andrews.

In pursuit of the ideal of Christ's Kingdom of Scotland, and the Covenant made between God and Scotland (first signed in Greyfriars Kirkyard in 1638 – but not by God), there followed a period of tremendous political and religious turmoil. Fife was seen as a hotbed of covenanting fervour in the second half of the 17th century. By 1679 the kingdom was forced to endure many companies of soldiers billeted in almost every community. Resentment ran high and when a group of

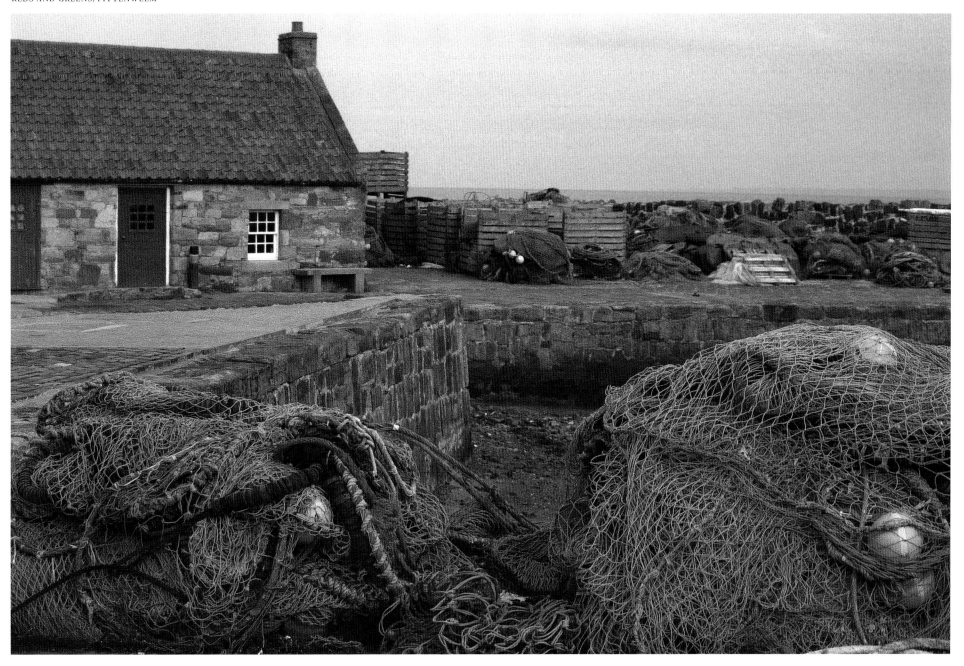

local lairds and farmers found themselves confronting a coach containing Archbishop James Sharp of St Andrews, they did not hesitate. The murder was motivated by the hated imposition of bishops on the kirk, by the ceaseless meddling of the restored Stuart king in what Scots had come to regard as their national church. Sharp's assassination shocked many but the cause which prompted it triumphed in the end. When the Stuarts were replaced by the genuinely protestant House of Orange in 1688, the Kirk rid itself of the unwanted bishops and some semblance of peace at last settled on Fife and across most of Scotland.

The tumults of the civil war and the covenanting period echoed across Europe. The Thirty Years War made tough soldiers out of men like the Leslies as it tore Europe in half. From 1618 to 1648 this unusually vicious and immensely destructive war rumbled across the continent, disrupting trade routes and sometimes destroying commerce entirely. Fife took its chance well.

Culross grew into a beautiful and well-set little burgh partly because of the acumen of a local entrepreneur, Sir George Bruce. With the help of exiled German engineers, Bruce extended his coal-diggings by means of shored-up galleries under the Firth of Forth, and so that ships could be more easily loaded, a shaft was excavated which came up through the waters of the firth – or at least in a shallow area of sandbanks. Creating an artificial island, called Preston Island, the shaft let air into the mine and allowed coal out. On the proceeds, Sir George extended and decorated the building known as Culross Palace and used his business contacts to best advantage. As ballast his ships brought back Baltic pine for construction and Dutch floor tiles for the comfortable and snug little rooms in what he called his Great Lodging.

Further east the Earl of Wemyss developed coal and salt production, exporting 60,000 tons a year by the early 1630s. Because of the disruption to European sources, the value of salt rose until it easily outstripped that of coal. At St Monans a squat little tower near the shoreline recalls all that industry. It was originally a windmill used to pump seawater up to the Earl's saltpans. The manufacture was so lucrative that owners sought to make their workers virtual slaves, labourers bonded by act of parliament, and they could also seize vagrants and force them to work at the pans.

When the European trade recovered after 1638, the demand for Fife salt contracted but high import duties kept the Earl of Wemyss and others in business in the home market. A famous Fife icon remembers the 17th century decline in the trade. The orange pantiles now seen on many roofs came as ballast in Dutch and other European merchant ships, but they were not the prized items they are now. Slates were much preferred, and it

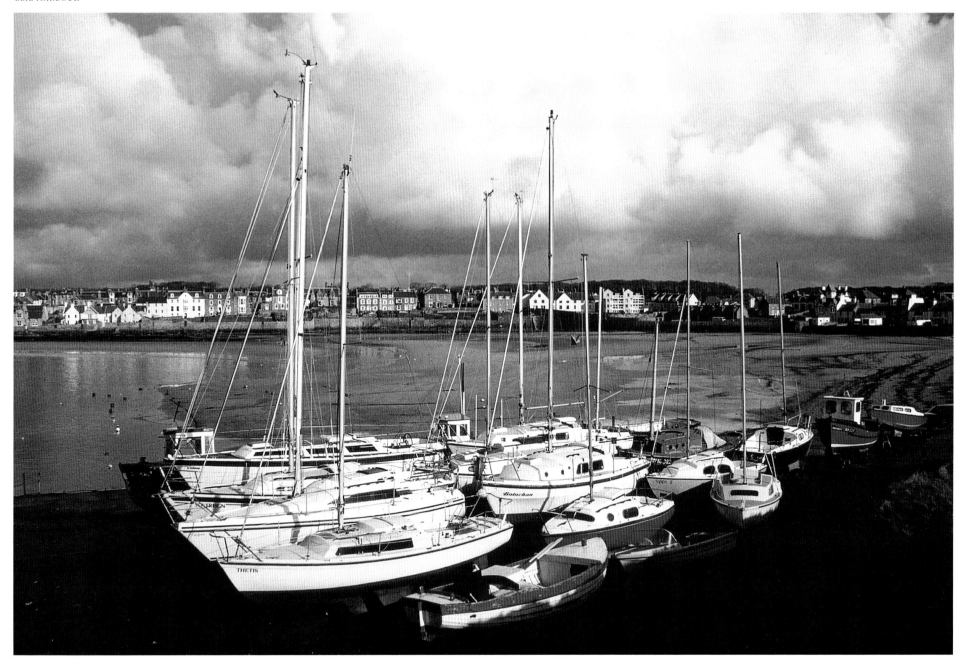

was as a symptom of economic decline that the cheaper pantiles first made an appearance in Fife.

As the Atlantic trade flourished on the western shores of Scotland, the Fife ports declined. The end of the 17th century saw hard times in the kingdom: between 1693 and 1700, the seven ill years of poor harvests brought famine, and the failure of the Darien Scheme visited ruin on those who had invested. Against a background of economic decline and failure, a parliamentary union with prosperous England held out some hope.

While the political price was heavy and power leaked steadily to Westminster, prosperity did follow – and relatively quickly. Within two generations of the Union of the Parliaments, the population of Fife began to climb as the economy developed and the demand for labour intensified. In fact between 1755 and 1991 the number of people living in Fife has more than quadrupled. At present there are 351,200 people living in the kingdom compared with only 81,750 in 1755. Across the same period other parts of Scotland have seen demographic trends run in the opposite direction.

The distribution of that population and the places where it increased most and least are generally reliable guides to how and where Fife changed in the modern period. Most startling is the fact that while numbers living in north and east Fife (the Howe, the Tay coastlands and the East Neuk) went up by 50%, the population of west and south-west Fife rocketed by 500% in the same 250 years. At least three dynamics were at work in bringing about such dramatic shifts.

As farming became more mechanised and less labour-intensive, people moved off the land and into the towns. This happened all over Britain and over an extended period. What began as the Agricultural Revolution of the late 18th and early 19th centuries has only recently slowed down. The average size of a Fife farm is around 360 acres (apparently this was governed by how long teams of plough and carting horses took to reach the furthest limits of the farm and then return at the end of the working day. If the acreage was too great, then that meant too much unproductive time plodding out to the fields and back to the steading), and in the late 18th century it needed 10 to 12 workers to make it fully productive. Now only the farmer and perhaps one other person work the land. In 1997 a mere 2,479 people worked in agriculture across the kingdom, a huge decline since the middle of the 18th century.

As more and more coal was dug in the south-west, the towns expanded, often because of the growth of coal-related industries such as the manufacture of lime or salt. When inland pits became viable, because of the spread of the rail network in the mid to late 19th century, the effect on population growth could be

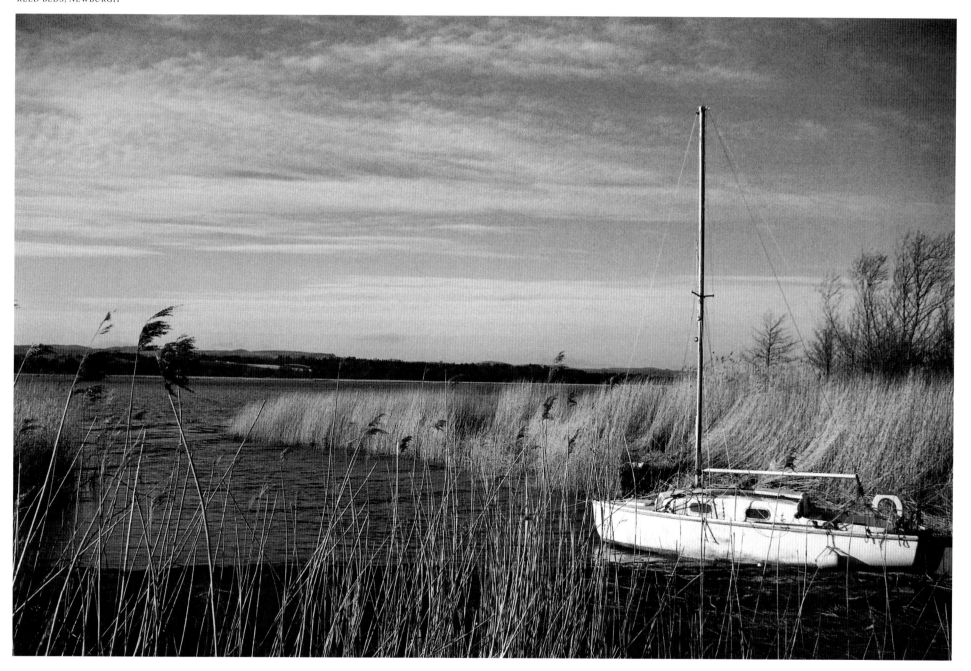

SALINE, ON THE WESTERN EDGE OF FIFE, ENJOYS VIEWS OF THE OCHIL HILLS

EDEN VALLEY FROM KEMBACK

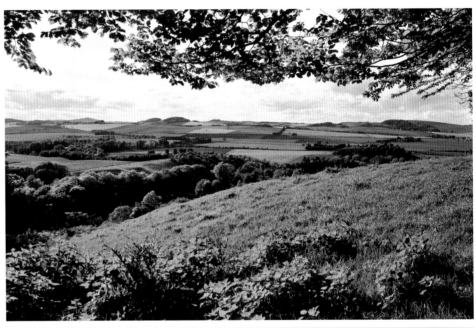

COAL TRAIN AT TORRYBURN, HEADING TO LONGANNET POWER STATION

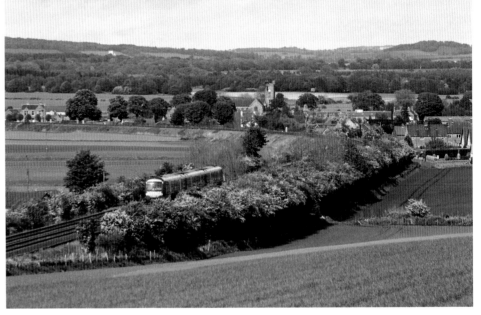

KINGSKETTLE

spectacular. In 1850 Cowdenbeath was a village of only 1,000 souls, but by 1914 and the outbreak of the First World War 24,000 lived there, most of the men working in the local pits.

Inextricably linked to the explosion of golf's popularity and the vogue for seaside holidays in the late 19th century, early tourism also prompted population movement. As the railways brought visitors to St Andrews and the golfing towns and beaches of the south coast, big hotels were built and these and others absorbed labour into a local economy which came to be dominated by the service industries. And as St Andrews University emerged from its 19th century torpor, it also began to become a significant employer.

Of all of these – and other – dynamics, coal was the most important. As mining became increasingly commercial, production usually being driven by the aristocrats fortunate enough to find it under their estates, and increasingly organised, Fife coal found markets outside the kingdom. Closest and most vibrant was the new Carron Ironworks near Falkirk. At first manufacturing cannonballs and then cannon to fire them, it had grown into the largest iron foundry in Europe by 1814 and the end of the Napoleonic Wars. Fife coal was shovelled into its blazing furnaces, delivered by lighters loaded at the coastal pits.

West Fife in particular was rich in coal deposits. In fact more than half of the 63 parishes in the kingdom had coal workings on some scale or other. The methods of extraction had improved from the era of coal-heughs and bell pits with what was known as the stoop and room method. Once a seam had been found and its direction traced by surface probes, miners followed it by leaving pillars of coal to hold up the roof and hacking out what they could find around them. It was extremely dangerous work, but in the absence of records, difficult to know exactly how dangerous. In such cramped and stiflingly warm places, small children were much used to carry off in baskets and primitive trolleys what had been mined by the men working in the near-darkness in front of them. Fatalities must have been commonplace, and by 1842 the Mines Act banned women and girls from working underground and the employment of boys under 10.

The problem of transport for such a bulky and comparatively cheap commodity dogged the early exploitation of Britain's coalfields but, as on Tyneside, Fife was blessed by having coal seams close to water, close to the coast of the Firth of Forth. That meant that water transport, boats being the only means of carrying bulk cargo until the coming of the railways, was readily at hand, and therefore cheap to operate. The presence of the seams near the coast also saw the rapid development of other, related industries. After the heights of the 17th

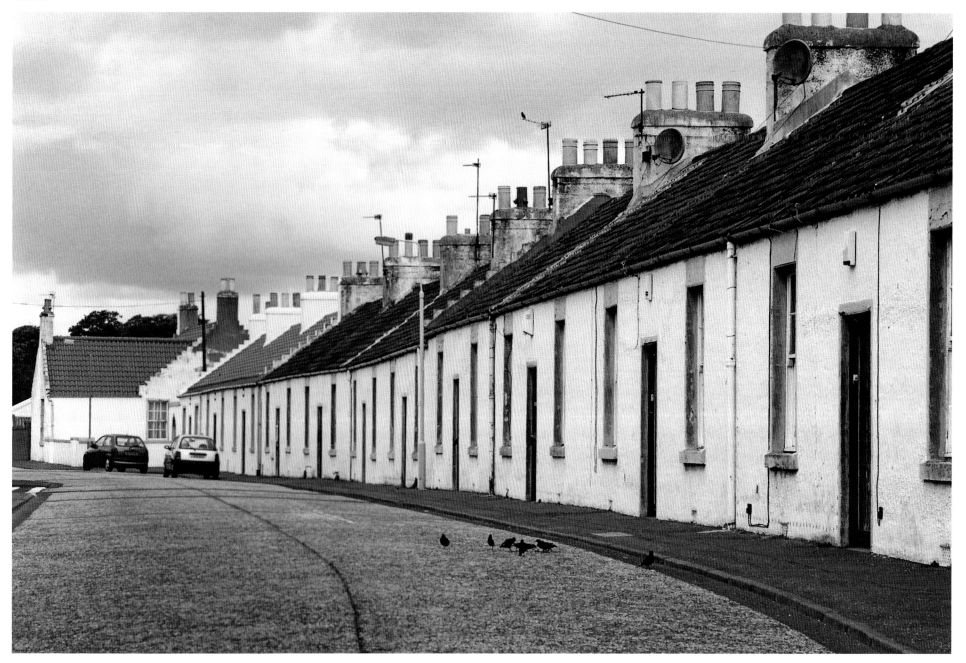

century, salt production had waned by the mid 19th century (although the last pans on the Forth were still working at Limekilns as late as 1946) but the lime-making industry gathered momentum. Limestone and coal could be easily brought together by boat and the rock burned to produce powdered lime. Needed in early chemical processes and also as a fertiliser in the new agriculture, lime was lucrative and production boomed. The discovery of deposits of limestone in inland Fife had the effect of suddenly making coal seams distant from the coast worth digging.

Charles, Earl of Elgin, owned the works at Limekilns on the shores of the Forth, in the extreme west of Fife, and he saw opportunities for expansion. At the new, planned village of Charlestown, he had 14 kilns built in the 1760s and once they were fully in production, around four shiploads of valuable lime were sailing out of his harbour on each working day. The streets of the village were arranged in the shape of an 'E' for Elgin, or perhaps ego.

Traffic on the firth must have been heavy. As the lime boats plied out of the Charlestown jetties, their skippers will have had to keep a wary eye on the ferries travelling across what was known as 'the narrow passage' between South and North Queensferry. The pilgrims of the middle ages had long ceased to come but merchants and men of business still needed to enter the kingdom. Ferries also crossed from Leith and Granton to Pettycur, Kinghorn and Kirkcaldy on the broad passage and there was a good deal of trade coasting between the Fife ports themselves. In the north, the narrower Tay was served by boats crossing from Tayport, Newport, Woodhaven, Balemerino and Newburgh.

Fishing had long persuaded Fifers to take to the sea, and though the East Neuk ports of St Monans, Pittenweem, Anstruther and Crail seem small to us now, they were busy places in the 18th, 19th and early 20th centuries. It is no accident that the Scottish Fisheries Museum is at Anstruther. Fish landed in Fife fed both Edinburgh and London. The latter market became possible in the late 18th century with the advent of fast sailing ships able to reach London before their cargo spoiled. It was the herring draves, the shoals which swam into the Firth of Forth in the late summer and early winter which presented the Fife boats with easy pickings. The Lammas Drave in August allowed men to go out in good weather, and fish close to home. Salmon from the Tay was also prized, especially by London tastes.

Fife is the only place in Britain where two such extremely hazardous occupations are to be found side by side. And it is instructive to note that Fifers believed even primitive mining to be safer than the fishing.

At the opposite end of the social and economic

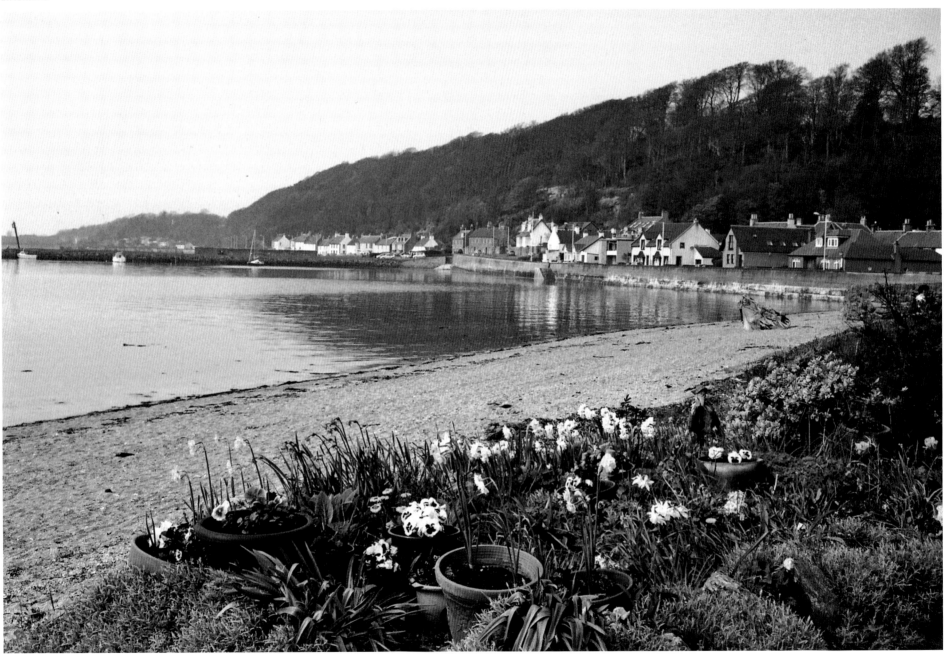

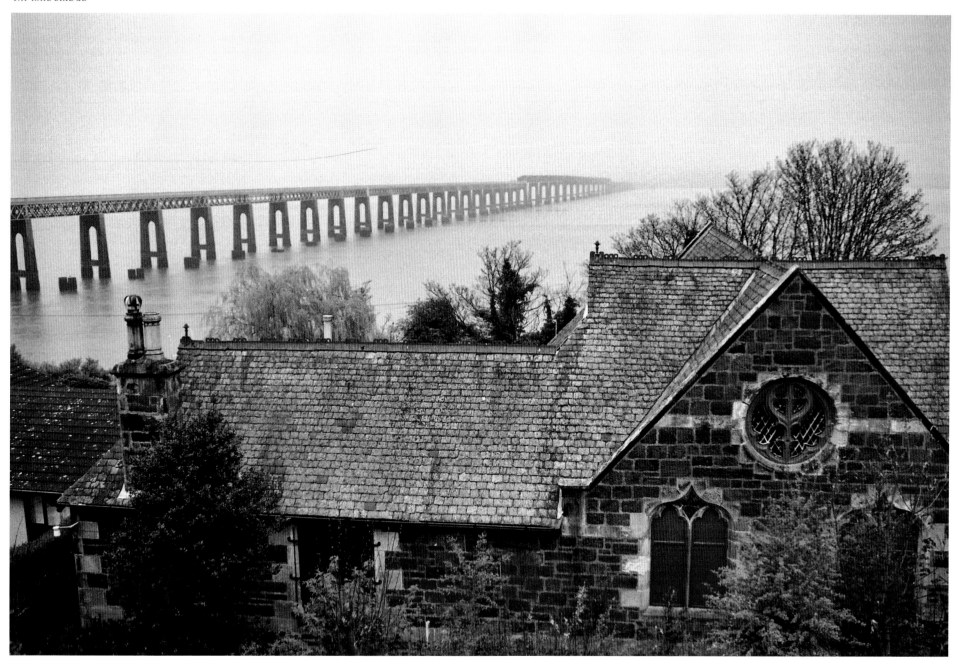

spectrum, Fife began to produce artists, musicians in particular. James Oswald was raised in Crail where he delighted listeners with his abilities as a fiddler. Growing out of the strong tradition linking music with the sort of communal work done in fishing communities, his talent later extended to the cello, originally known as the violoncello, an instrument new to 18th century Scotland. Oswald moved to Dunfermline to work as a dancing master. Polite society in Fife was evidently becoming ever more polite. Perhaps through the burgh's continuing royal connections, Oswald was approached by the court of George III, and he went to London as the king's chamber composer. Almost entirely forgotten now, his Airs for the Seasons was a popular composition, much influenced by the fiddle music Oswald first heard amongst the fisher folk of Crail.

His near-contemporary and another talented musician was Fiddler Tam frae Pittenweem. More properly known in the polite society of Fife as Thomas Erskine, Earl of Kellie, he was tremendously prolific, composing string quartets and symphonies. By the time of his premature death in 1781, Fiddler Tam had acquired a national reputation. Here is part of his obituary from *The Gentleman's Magazine*:

> His Lordship was one of the first musical composers of the age, and esteemed by the cognoscenti as the first man of taste in the musical line, of any British subject, and ranked all over Europe in the first musical form.

As well as creative artists in their own right, Fifers could also supply inspiration. Showing a characteristic thrawness, Alexander Selkirk, a sailor from Largo, demanded to be put ashore on one of the uninhabited islands of Juan Fernandez off the coast of Chile. He had been in dispute with his captain and refused to continue working on the same boat. Rescued after five years of living and surviving alone, Selkirk returned to London where he told his story many times. Daniel Defoe took the tale as the inspiration for *Robinson Crusoe*, the first true novel in the English language. Selkirk returned to Largo but never settled. Abandoning his house, he lived in a shelter in the backlands and local children were amazed at his affinity with animals. He was known as the man who could teach cats to dance.

Of the eighteen royal burghs in the kingdom, all but five lie on the Forth coast, the places where coal, its related industries and fishing were important. But the development of the burghs in the modern era can be readily seen in their municipal buildings. The old tolbooths, the early versions of a civic centre, at Crail, Culross, Strathmiglo and West Wemyss are more or less in their original states, and have not been replaced.

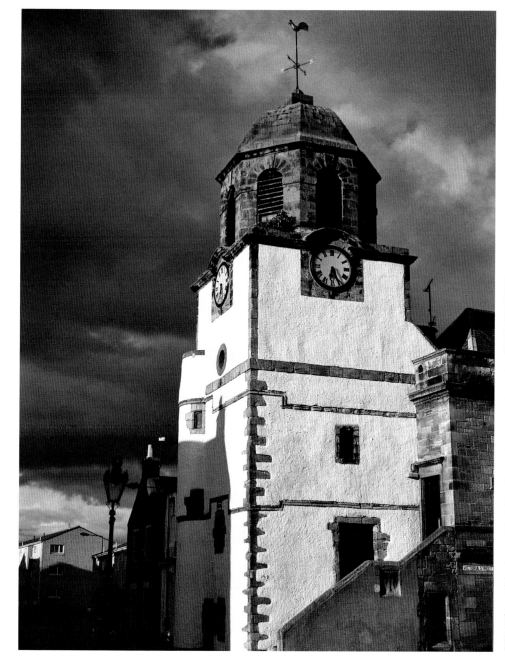

124

Because these burghs did not expand very much in the last three centuries, there has been no need. At Dunfermline, Kirkcaldy (which absorbed Dysart), Cupar and St Andrews town halls were built, some of them grand, and other civic buildings appeared in the course of the 19th and 20th centuries.

The growth and prosperity of Dunfermline and Kirkcaldy was stimulated by an industry which has all but disappeared in Fife. Only a place-name remembers it. Lying between Cupar and St Andrews, the village of Dairsie is also known as Osnaburgh. It was originally a type of coarse linen, one of various sorts made all over the kingdom. Canvas was woven in Kirkcaldy and fine damask table cloths made in Dunfermline. Many towns and villages were involved in the linen trade and a giveaway street-name often tells the sharp-eyed which. Bleach fields were open spaces where linen was laid out to catch as much of the sun as possible and become whiter as a result. Bleachfield Court in Dunfermline is only one example.

Flax was either imported through the Fife ports from Holland and the Baltic or grown from lint seed. Farmers thought it a hungry crop and when flax or lint, as it was often called in Fife, was harvested, it had to be pulled up by the roots. At one point in the process of manufacture, the plant fibres were drawn through a heckle, a board with rows of long iron teeth sticking out of it. As linen was increasingly produced in a semi-industrialised system (taking its manufacture away from villages and into towns), heckling sheds were built and the men who did this difficult and tedious work often paid someone to read to them. Newspapers and pamphlets were favoured and gradually hecklers became a very well informed group. At public meetings and gatherings they were liable to ask pointed and discon-certing questions. In this way awkward interruptions at meetings became known as heckling and as the linen industry mechanised and made these men redundant, their name lived on in an entirely different context.

By 1915 only 6,000 people worked in linen making in Fife. Gradually output has withered and now the tradition is almost lost. However, a by-product of Scotland's linen manufacture, the British Linen Bank, was revived in the guise of a merchant bank in 1999.

In the 19th and early 20th century famous sons of Fife made a national and international impact outwith the kingdom, but later left their indelible mark in many of its towns. Born the son of a weaver in 1835 in Dunfermline, Andrew Carnegie made a vast fortune in the United States. Speculating at first in shares in the new railway companies and then founding his own iron and steel empire, he was ruthless and single-minded. When Carnegie sold his business in 1901 to US Steel, he immediately began to give away his huge wealth. Much

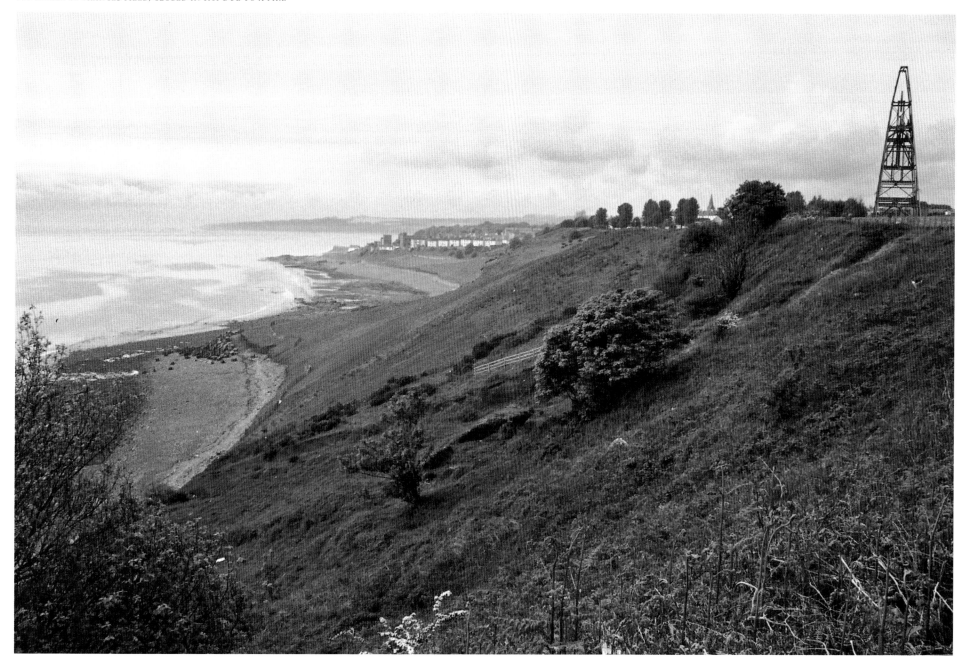

of his generosity is remembered in the 2,811 libraries he endowed, and to Dunfermline, 'the most sacred spot to me on earth', he gave princely gifts. Unlike some rich men, Carnegie was unquestionably a force for good and he changed Fife for the better.

The minister for the parish of Kilmany, between Balmullo and Gauldry, also believed that he had helped change Fife for the better, but only reluctantly. Thomas Chalmers was born in Anstruther, educated at St Andrews University and later became Professor of Moral Philosophy both there and at Edinburgh University. In the late 1830s, he led what has been called the rebellion of the pious, and his actions changed townscapes all over Fife. The Church of Scotland became divided over the issue of patronage, over who had the right to appoint ministers. Should it be the local laird or was it the right of congregations? Chalmers believed profoundly in the latter cause and in 1843 he led

like-minded ministers out of the established kirk to form the breakaway Free Church of Scotland. Over a third of the establishment left and, with extraordinary energy, Chalmers set about creating a new national church. In the centre of many Fife towns, and all over Scotland, new churches and church halls were built, a new divinity college founded in Edinburgh and much else. Five hundred new kirks went up in only two years. Further splits and reunifications took place, until by 1929 differences had been largely patched up. But the Disruption of 1843 left Scotland with many more chuches than were needed, and looking to visitors like a very devout nation.

Farming also employs many fewer in Fife, but at least it continues and sometimes profitably. Since records began in the Roman period the grain grown in the kingdom has always been reckoned valuable and of high quality. The microclimate has had a pronounced

effect. Even in this era of profound change, there appears to be a pattern to Fife weather. In the west the average annual rainfall is approximately 90cm, while in the far east it drops to 50cm. Over a relatively short east/west axis, this is a substantial variation and it has meant that cereals have been grown mainly in the Howe of Fife and the East Neuk. From the 1760s grain was exported to London markets through Newport, St Andrews, Elie and Kirkcaldy but now much of it travels a shorter journey to the huge distillery, one of the largest in the world, at Cameron Bridge near Leven.

Hay was historically a valuable cash crop for Fife farmers. When industry was literally pulled by horse-power, the big Clydesdales and others had to be fed. Thousands of heavy horses in Dundee, and the busy centres of Dunfermline, Kirkcaldy, Methil, Buckhaven and Leven depended on a year-round supply of good hay since many of them had no access to grazing and

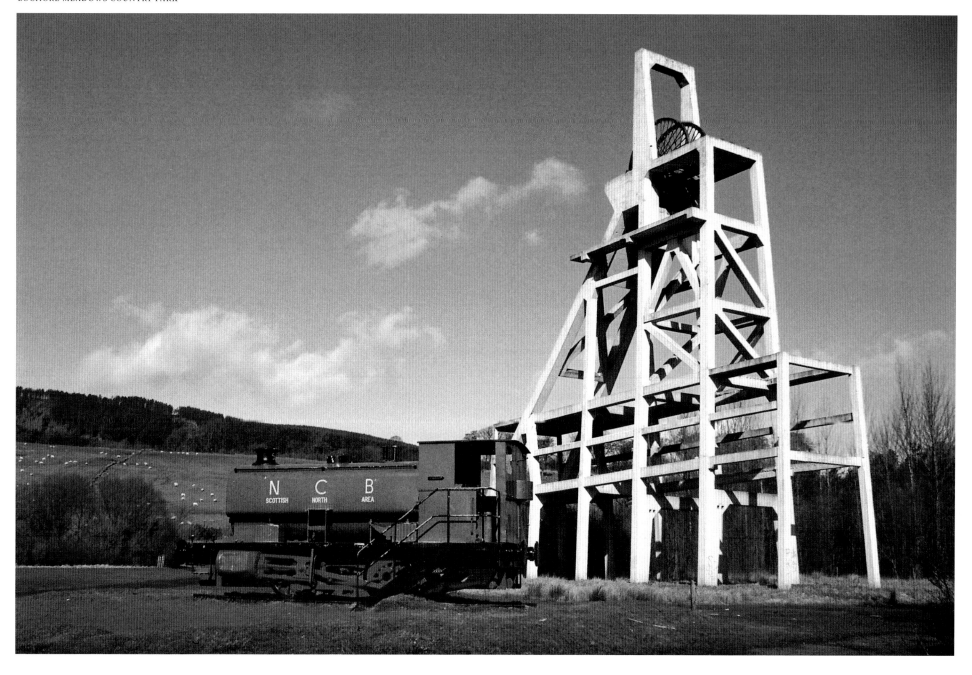

were kept stabled when not earning their feed.

Working horses clopped along Fife's streets and roads until well into the 20th century, but by the middle of the 19th the iron horse was about to revolutionise the British economy. Coal drove the development of railways in Britain, both track and locomotives. Not only did the expanding network connect existing towns, it helped to create new ones. The inland coalfields were opened up when railways reached them and made the extraction of coal a paying proposition. Villages like Lochgelly and Ladybank became small towns and others grew together and united into single burghs, like Buckhaven, Methil and Innerleven.

The railway linked Fife industry with British and world markets, but geography remained an inhibition. In 1850 the first rail ferry in the world took wagons across the Forth from Granton to Burntisland. Piers were built well above the high tide marks and slipways enabled wagons to be loaded onto the ferry without the use of cranes. Appropriately it was called The Leviathan. Able to make five or six return trips from Granton to Burntisland each day and to take as many as 34 wagons on any given trip, the ferry was worked hard. The effect of the service was to make Fife coal both available and cheap in Edinburgh, and also to carry a variety of other goods manufactured in the kingdom. The Leviathan was undoubtedly a great feat of engineering in itself – but it was not satisfactory. Bad weather prevented crossings and even six a day could not cope with a backlog. Bridges were needed.

Much narrower and more shallow than the Forth, a rail bridge over the Tay seemed a straightforward proposition. Plans were made as early as 1854 but work did not begin until 1871. Sir Thomas Bouch's design included a middle section known as the High Girders which was tall enough to allow ships to pass under it.

Queen Victoria opened the new bridge on 1st June 1878. It was to stand for less than eighteen months.

On the night of 28th December 1879 a devastating storm blew down the Firth of Tay. Part of Kinfauns Castle collapsed and many houses had their roofs blown off. When the storm hit a train crossing the high girders section, the impact was catastrophic. The entire central section and the train plunged into the icy waters of the Tay. Eighty lives were lost, and an enquiry laid the blame squarely on Sir Thomas Bouch, concluding that the project had been badly designed, badly built and badly maintained. Beside the piers of the collapsed bridge and on the same line, a second Tay Bridge was begun almost immediately. Completed in 1887, it still stands.

Before the disaster of December 1879 and in the afterglow of the opening of the first Tay Bridge, Sir Thomas Bouch had been commissioned to build

136

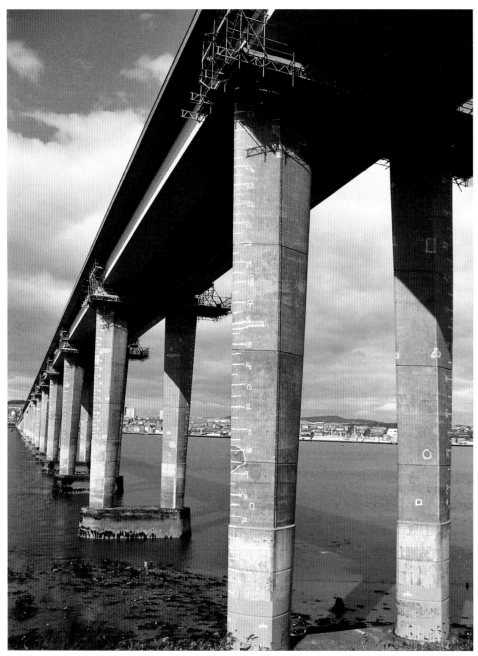

something similar across the Forth. Plans were hastily shelved, and a completely new concept devised. Sir John Fowler and Benjamin Baker proposed three huge double cantilevers linked by long girder spans and anchored on each shore by 1,000 ton counterweights. The result is massive but elegant, and perhaps the most distinctive structure in all of Scotland.

On 21st January 1890 two long and very heavy trains rumbled onto the Forth bridge, travelling slowly and side by side from the south bank. Each weighed more than 900 tons and as they opened up the throttles to pick up speed, the drivers no doubt remembered what had happened on the Tay twenty years before. More than a hundred years and hundreds of thousands of crossings later, the bridge remains one of the wonders of the engineering world. And its correct name is The Forth Bridge, since it was created long before its neighbour began to carry road traffic in 1964.

As innovation imported people, goods and services across the Forth into Fife, new thinking – not to say genius – was being exported. Adam Smith was baptised in Kirkcaldy in 1723, probably born some time after his father's death. At the age of four, the boy was kidnapped by a band of gypsies before being rescued by his uncle. Such excitements may have left a mark on his character, but he settled to an education at the Burgh School and then at Glasgow University. Appointed Professor of Logic in 1751 and then of Moral Philosophy a year later, his Theory of Moral Sentiments made an immediate impact but in 1764 he resigned his chair and eventually returned to Kirkcaldy to live a bachelor life with his mother. Over the next ten years he laboured over his most famous and most influential work, *An Inquiry into the Nature and Causes of the Wealth of Nations*. One of the least read but most plundered and quoted books ever written, its impact can still be felt in modern politics.

Smith is claimed as an inspiration by both ends of the political spectrum, something which would have pleased him immensely.

Party politics in Fife began early. As the 19th century wore on, a series of reform bills widened the franchise to include more and more voters. Liberals and Conservatives alternated in the constituencies of East Fife and West Fife (prior to these was St Andrews Burghs, a constituency which included Cupar, Anstruther, Crail, Kilrenny and Pittenweem). And at the beginning of the 20th century they still held sway. Two families appeared to dominate in the east. The Ellices had been Liberal MPs, off and on, since 1837 and the Anstruther-Grays Conservatives since 1885. The General Election of 1906 showed how close fought their rivalry was. With only a comparatively tiny electorate to convince, Major William Anstruther-Gray scraped home by 23 votes against Captain Edward Charles

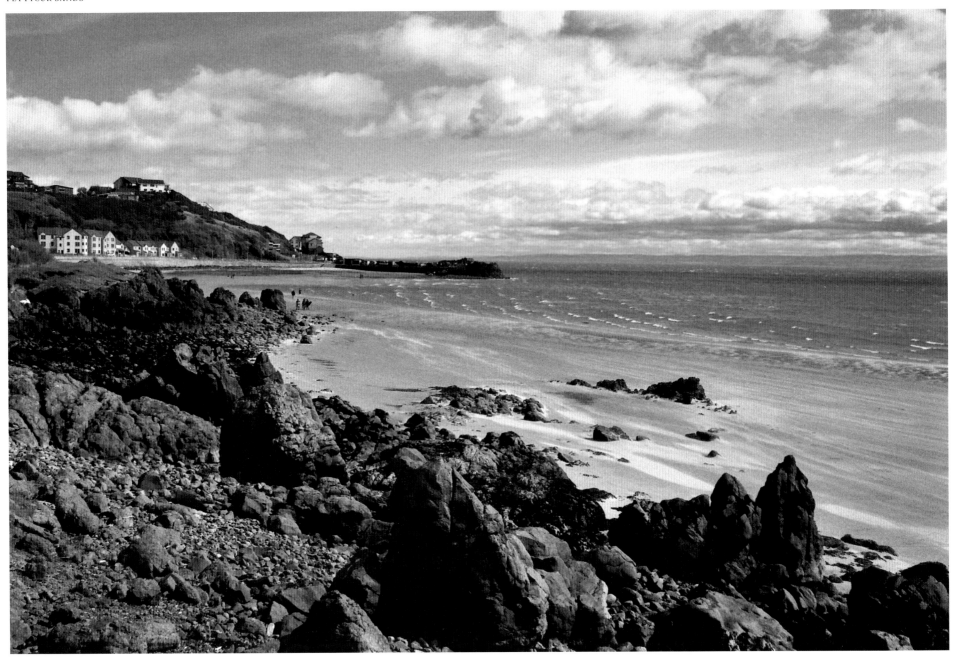

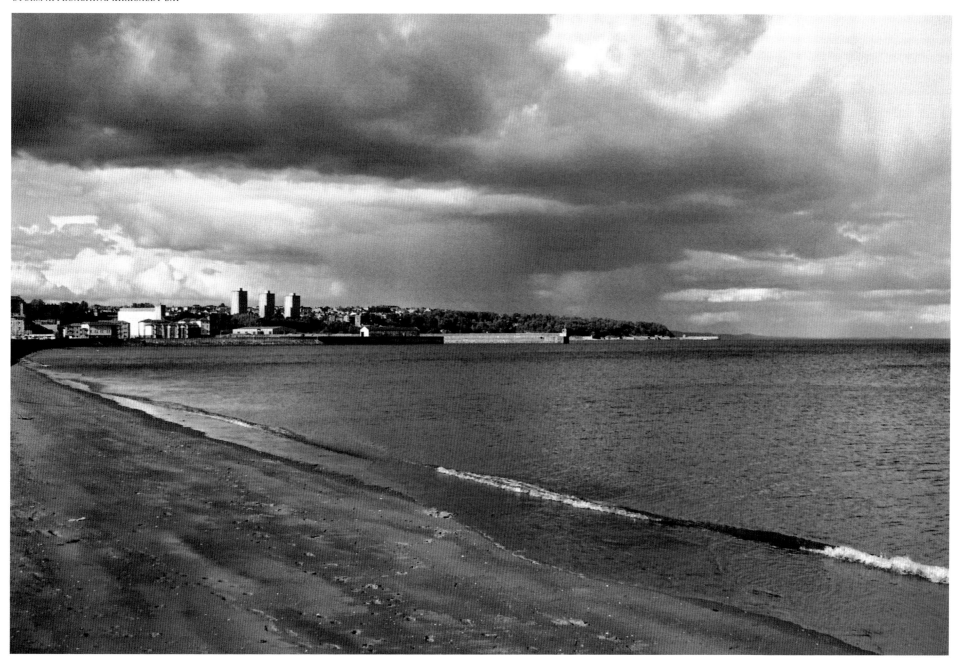

Ellice. Fewer than 3,000 voted. In 1910 Ellice had his revenge.

Over in West Fife the two General Elections in 1910 saw a new party in contention. In January the Labour Party came second, and by the following December, they won the seat. After the First World War, the General Strike of 1926 and the much longer miners' strike (it lasted on into the winter of 1926/27 and created great hardship in Fife), the Communist Party put up a candidate against Labour in 1929. Willie Gallacher came second, and in 1935 he became the first Communist MP to sit at Westminster. Winning again in 1945 (when he was joined by Phil Piratin who won the London seat of Mile End for the CP), he held on until 1950. West Fife continued to be a very visible constituency when the republican Labour MP, Willie Hamilton, held it for more than twenty years.

Boundary reorganisation has seen Fife split into three seats: North East Fife and Dunfermline are currently (2007) held by the Liberal Party and Kirkcaldy by Labour. When the first elections for the Scottish Parliament were held in 1999 Fife acquired an alternative political complexion: the north east remained Liberal but Fife Central, Kirkcaldy, Dunfermline East and Dunfermline West all went Labour. As much as anything said or done by politicians, this split reflects the legacy of geology, of the time when the supercontinents of Laurentia and Gondwanaland collided, drifted south to the equator, rifted to acquire coal sediments and moved north again. As often in Britain, places where the grass grows and cows graze vote Conservative or Liberal, and where coal is dug, they vote Labour. All of that was settled a long time ago.

Geology bequeathed something else of great importance to Fife. As sea levels fluctuated after the ice ages, raised beaches, known as links, were created. The word appears to be of Northumbrian origin, is cognate with the word flank, and seems to mean rising ground. Sheep grazed the links, kept the grass short and scraped out bields from the sandy soil. These came to be called bunkers, an old word for a seat (a place where a low ridge of soft and comfortable turf overhung a sandy patch) and as strips of common ground, the links became a place for what leisure time there was.

Some time in the 15th century, and possibly earlier, people began playing a game with sticks or clubs and stones or balls. The first golf games on the links were probably contests between players trying to hit a ball between two landmarks in the least number of shots. By the mid 18th century the links had become courses and golf clubs had begun to form. In 1754 the first map of what became the Old Course was made and the Society of St Andrews Golfers was formed. When it was endorsed by King William IV in 1834, it renamed itself

142

The Royal and Ancient and when the New, the Eden and the Jubilee were laid out, the original course became old and grew into the most famous in the world.

From St Andrews the Royal and Ancient sets the rules followed in world golf, and the town can fairly claim (with some dissent from East Lothian and Ayrshire) to be the home of the game. By the early 1800s golf balls and clubs were being made semi-industrially in the town, and also at Anstruther, Leven, and Kinghorn. The old cathedral city has certainly become a magnet for golfing tourists and their long-suffering families, and in some ways pilgrimages to the Old Course have at last compensated for the loss of pilgrims to the shrine of St Andrew.

Other places in Fife can claim a share of golf's early history. At Elie and Lundin Links, two of the very best courses in the world can be played by high handicappers able to afford the modest green fees. At Kingsbarns a new course has been laid out and it is said to rival many of the more venerable as a proper test of links golf. Many Fife courses look innocuous to the naked and untutored eye, a series of undulations, patches of long tussocky grass and displaying a complete lack of all the manicured drama of lakes, creeks and azaleas so beloved of North American clubs. But when the wind blows, and it blows often, these patches of liminal land can produce true champions, players able to flight the ball, dodge the pot bunkers, read the grain of the land and reclaim the ancient spirit of the best game in the world.

Geology has also gifted Fife a substantial tourism and service industry based on golf. But there has long been more to the kingdom. In the 1790s visitors were coming to Burntisland and Elie for the sea bathing, then seen as a bracing cure for all manner of ills. Retirement homes were being built in the 1850s at Lundin Links, Tayport, Newburgh and Newport and when the railways came soon afterwards, Edinburgh came to the East Neuk villages for day trips and later for longer. Now it is believed that 7,000 people make their living in hotels, restaurants, shops and all the other services related to tourism in Fife. Aside from the public sector, it is probably the largest industry.

While golfers were making their way sedately around the kingdom's links, more explosive energy was being expended on local football pitches. Mass sport in Britain, both for players and spectators, began in the later 19th century when working men were first given a Saturday afternoon off work. As the five and half day week became common, so did football. Cowdenbeath is the oldest professional club in Fife, formed in 1881 (or 1882) and now – inexplicably – known as the Blue Brazils. Their glory days were from 1924/25 to the mid 1930s when they played in the old First Division and had three players capped by Scotland. And more recent

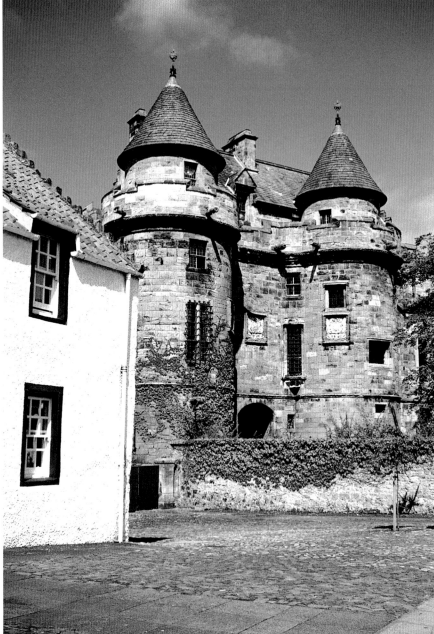

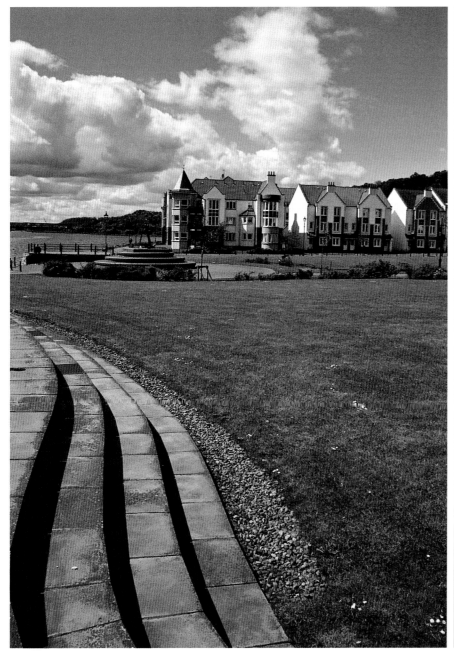

success came when their manager, Mixu Paatelainen, led them to the Third Division title. Apparently the terracing chanted that There's Only One Mixu Paatelainen!

When Kirkcaldy's Raith Rovers won a signal victory in the 1960s a BBC commentator reputedly guessed that their supporters would be dancing in the streets of Raith. It was not David Coleman who blundered but Sam Leitch who, as a Scot, should have known better. Raith Rovers have occasionally sparkled and more than a thousand faithful fans generally turn up at Stark's Park to support them. Recently the club's future was assured with a £1.2 million community buyout. At Methil, East Fife has occasionally roused the stalwarts of Bayview but, like Raith and Cowdenbeath have more often found themselves in the lower echelons of Scottish football.

Nevertheless Fife produced and Raith Rovers fielded one of the greatest ever Scottish footballers. Born in Hill of Beath in 1939, Jim Baxter began his playing career at Stark's Park in 1957. Having spent three glorious years with Raith, he moved to Glasgow Rangers. For many his place in history rests on a single match, when he played at Wembley in 1967 against England. Using his extravagant skills and langorous arrogance to taunt the opposition, he helped Scotland defeat England by three goals to two. They were World Champions at the time, but Baxter enraged and baffled their famous defence by playing keepy-uppy down the touchline.

Like many football and rugby clubs in Scotland Dunfermline Athletic grew out of a cricket club. In 1885 the football section severed connections to become D.A.F.C. and of all the Fife clubs, it has performed best in the modern era. But perhaps its most extraordinary achievement was in avoiding relegation rather than winning anything. In the season 1958/59 Dunfermline had to defeat Partick Thistle by nine clear goals to avoid the drop into Division Two. An apparently impossible task. Partick Thistle were placed above Dunfermline in the league, and not themselves in danger of relegation. But the impossible happened, Dunfermline won 10 – 1, perhaps their greatest victory.

In contrast with football, a world where ordinary working men with talent could rise and be celebrated, universities remained largely the domain of privilege – and gender prejudice. In 1862/63 Elizabeth Garrett matriculated as a medical student at St Andrews, but was not allowed to attend classes. By 1876 women did begin to break down the walls of Academe. Not allowed to take the same degrees as men, they followed a genteel alternative known as the LLA, the Lady Literate in Arts. It was popular and by the time the courses were wound up in 1932, more than 36,000 literate ladies had tiptoed

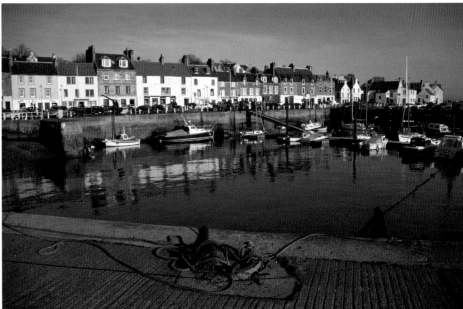

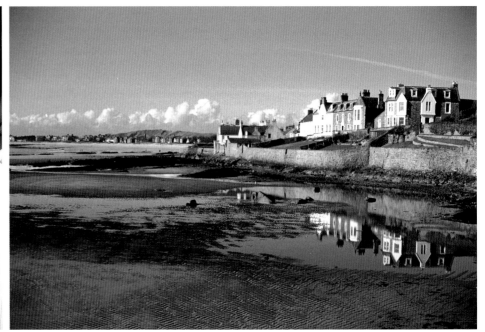

WEST SHORE, PITTENWEEM

ELIE WITH EARLSFERRY IN THE BACKGROUND

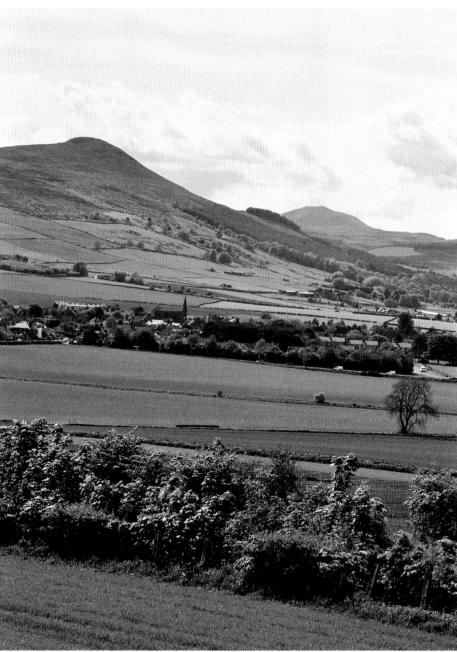

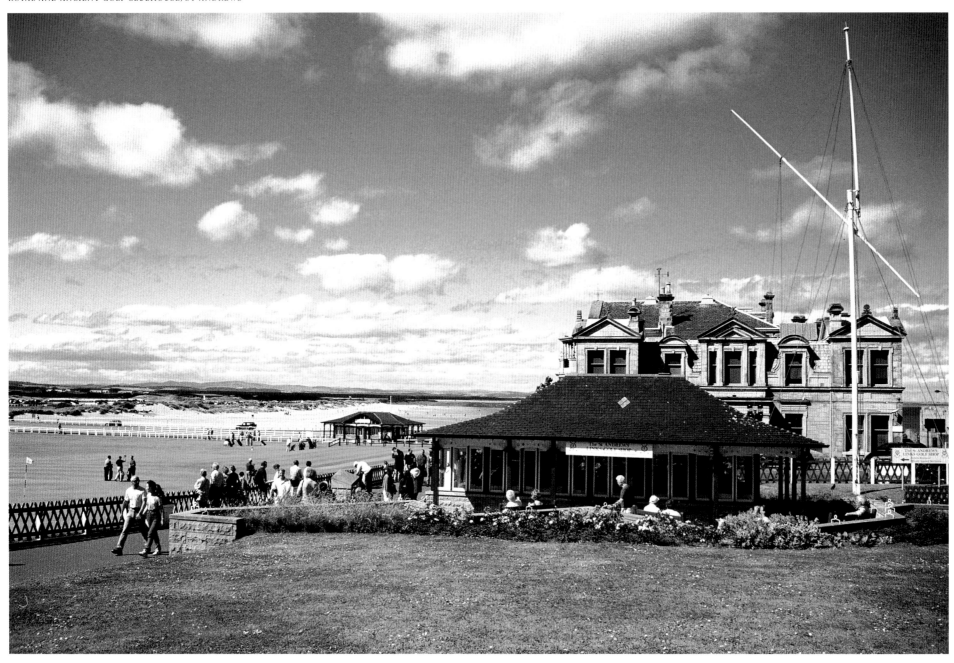

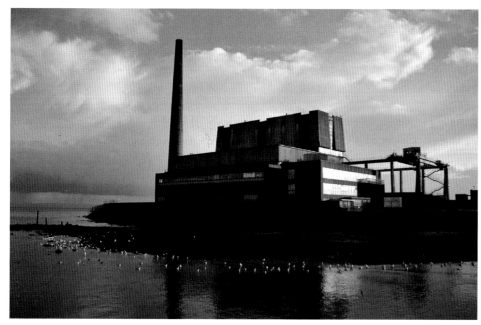

DISUSED SHOP, ANSTRUTHER

CAFE, BURNTISLAND

their way through the standard texts at St Andrews. In fact women had been able to matriculate in degree courses with men since 1892, and four years later a women-only hall of residence opened. Even now University Hall remains exclusive.

Around the same time as Dunfermline were trouncing Partick Thistle, more educational barriers were tumbling down. Changes in legislation created the opportunity for clever children – from whatever social class – to find a place at the like of St Andrews University and also be given a maintainance grant to make it possible for them to go. From the early 1960s universities grew apace and expansion was essential. But in the case of St Andrews, it was almost fatal. In 1967 what had been Queen's College, and part of St Andrews University, became independent as Dundee University. The number of students left at St Andrews dropped to an unviable 1,900 and radical measures had to be taken

quickly. After a flurry of new building and recruitment, numbers had risen to a more healthy 3,000 by 1972, and now they stand at 6,200.

Such was the pressure on accommodation in the late Sixties and early Seventies that the university authorities began to help students and staff find places to live in Crail and Anstruther. The East Neuk fishing ports seemed sleepy and picturesque, places where only the cry of the gulls and the gentle lap of the tides interrupted academic study and other things. It was a misleadingly peaceful picture.

Up until 1948 Crail, Anstruther, St Monans, Pittenweem and Elie had been buzzing, busy fishing ports. Throughout the world no fishery was larger than the late 19th century Scottish herring fleet, and barrels of salt and cured herring sold all over northern Europe. More than two hundred boats sailed out of Anstruther and Cellardyke alone. The Fife harbours saw so much

traffic that none could accommodate the number of boats registered; in fact Cellardyke had three times the number actually able to berth there. The great fishery peaked in the 1930s. And then cataclysm struck. Quite suddenly, in the autumn of 1948 the herring shoals failed to appear in the Firth of Forth.

This meant a rapid decline and a swing towards the much more expensive deep sea fishery. After 1948 the Fife fleet shrank and with the imposition of more and more quotas, it has continued to shrink. St Monans is now the busiest port with more than thirty boats based there.

As the fishing industry ebbed and flowed in the 19th and 20th century, Fife's output of linen fell. But one by-product came to be associated with the kingdom, and it was celebrated – not entirely lyrically – in poetry. Here is the relevant verse from Mabel Campbell Smith's 1913 poem, 'The Boy in the Train':

I'll soon be ringing ma Grandma's bell
She'll cry, 'Come ben, ma laddie!'
For I ken ma'sel by the queer-like smell
That the next stop's Kirkcaldy.

Linoleum was not invented in Kirkcaldy but the town made it famous. The word derives from the Latin words for linen and oil and the name and process were patented in 1863 by Frederick Walton, an English inventor. Solidified linseed oil, the source of the queer-like smell, was used to coat canvas and make a hard-wearing floor covering. Cold, slippery, but hard-wearing.

As its specialism in the linen manufacture, Kirkcaldy already made canvas, much of it used for sails. Floorcloths, so-called, had been produced with canvas at Michael Nairn's factory in Pathhead but with Walton's process, Nairn's began to print patterns on the lino and business quickly expanded. In the 1890s there were eight manufacturers in Kirkcaldy and one based at Newburgh on the Tay coast. Only with the coming of cheaper carpets in the 1960s did the industry see a dramatic decline, but Nairn's survived by diversifying into vinyl tiles and cushionfloor vinyl.

The 1890s also saw a peak of iron-founding in Kirkcaldy and a general build up of heavy industry in the decade before the outbreak of the First World War. By 1914 there were 27,000 miners in Fife and output had climbed to 9,000,000 tons a year. Coal still powered much of the work of the kingdom, and although new industries did come in the 20th century (the naval dockyard at Rosyth, an aluminium plant at Burntisland), it was mining which dominated the minds of economic planners until well into the 1950s.

In 1947 when the Labour government nationalised the coal industry, 33 collieries were working in Fife and more than one in five of all workers were miners. A year later Glenrothes was established as a new town, its future to be built on the success of the Rothes mine, what would have been called a super-pit in the 1970s. To alleviate acute housing problems in Glasgow, the overspill population would come to live in central Fife.

Coal-burning power stations were built near to pits with rich and long-lived seams. In 1960 Kincardine rose by the shores of the Forth, Methil Power Station came on stream in 1963 and Longannet in 1966. Politics, geology and bad luck meant that the strategy failed, almost entirely and very quickly.

The Rothes pit was fatally prone to severe flooding and had eventually to be abandoned. New towns nearer Glasgow (allowing decanted families to keep in touch with relatives more easily) at Cumbernauld and East Kilbride absorbed the overspill population and Glenrothes' target of 55,000 inhabitants was never reached. Now 39,440 live in the town, and its economy

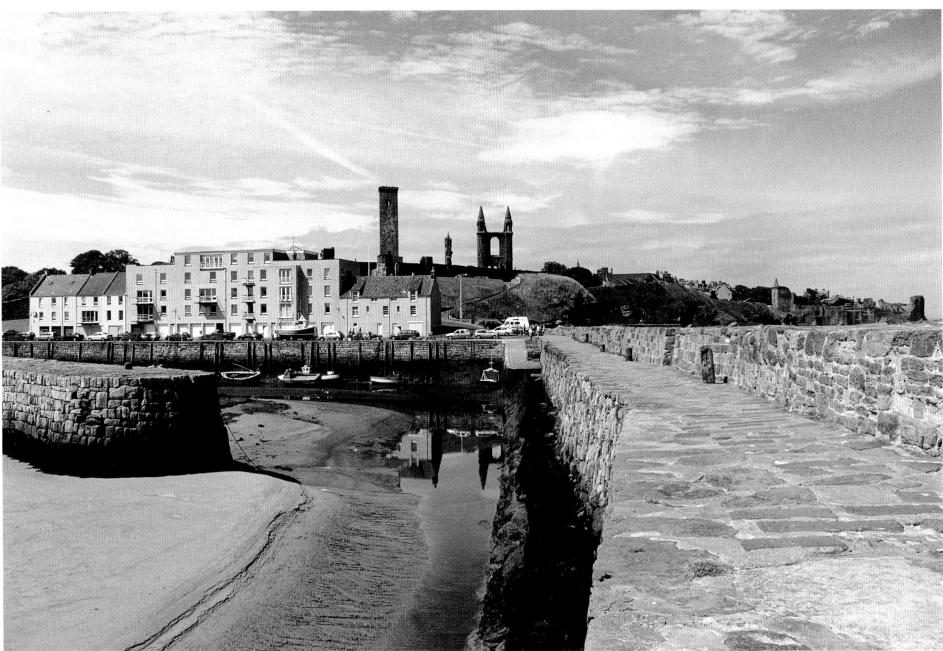

JIMMY SHAND MEMORIAL, AUCHTERMUCHTY

'JIMMY THE HORSE' ON A DELIVERY RUN IN BURNTISLAND

WESTERN AVENUE BRIDGE, GLENROTHES. FROM THE GROUNDS OF LESLIE HOUSE

PITREAVIE BUSINESS PARK, DUNFERMLINE

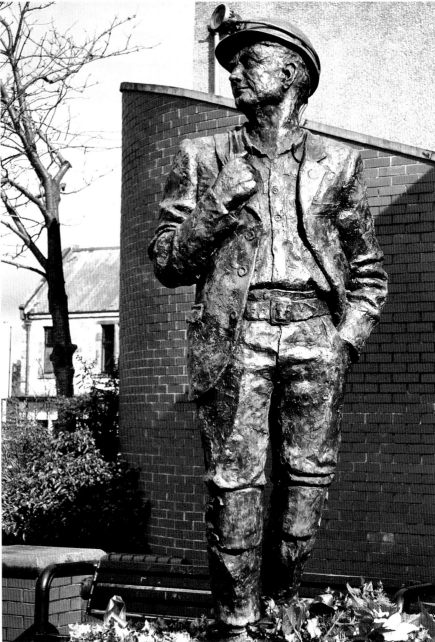

has been rescued by the coming of new industry and the relocation and basing of the local authority's headquarters.

The power stations' appetite for Fife coal was much reduced by the costs of extraction. The Fife and Forth coalfield still holds high reserves but efforts to win the coal have been badly hampered by expensive flooding, and occasionally by fires, as at the Michael Pit. But it may have been politics which sealed the fate of the coalfield more certainly than the complications of technology and geology.

In 1973 the National Union of Mineworkers objected to the Conservative government's incomes policy and the resulting strike led to a three-day working week and a long list of restrictions brought about by the shortages of electricity. Led by Charlie Gormley, Michael McGahey and the Fife miners' leader, Lawrence Daly, the NUM were implacable. Edward Heath, the

Prime Minister, called an election on the issue of who ruled the country. The answer supplied by the electorate was – not you. And a Labour government returned to power. Conservative politicians never forgot the lessons of the 1973 strike and when inept and dogmatic leadership presented Margaret Thatcher with an opportunity to humble the NUM, she took it.

In 1984 and 1985 the tragedy of the miners' strike led by Arthur Scargill unfolded. The industry was devastated. Pits closed all over Fife and the number employed in mining between 1981 and 1991 halved. By 1997 only Longannet and Castlebridge were working as deep mines, and at present fewer than 2,000 work on mainly open-cast operations. The coal is still there, but the economic and political cost of bringing it to the surface has been too great.

Other industries have flourished in the vacuum. Electronics, with its high value and small bulk, has

established itself. By the 1950s paper-making had become important in the kingdom, with seven mills in production. Amongst the largest were Tullis Russell at Markinch and at Guardbridge. After the last coal shipments sailed out of Methil harbour in 1970, an oil rig fabrication yard was set up and at Mossmorran a large petrochemical plant was commissioned in 1981.

Other related industries have established themselves in West Fife, and with the building of new housing in places like Dalgety Bay, population levels have stabilised. As the Edinburgh economy continues to expand, it may be that its growing housing shortage will be met across the Forth in Fife. Transport links will need to improve to enable that. In the 1930s and 1950s in particular, tourism to Fife, encouraged by golf and beautiful beaches, developed a great deal before being dented by the rise of the foreign package holiday.

It may regenerate as anxieties about global

166

warming encourage people to take holidays nearer home. As with much of the rest of Scotland, local government, based at Glenrothes, has grown into Fife's largest single employer.

· · ·

Geology shaped Fife, made it a kingdom and laid out its rolling farmlands, coal seams and long sea coasts. Eleven thousand years ago the ice sheets retreated, and the melting glaciers bulldozed and scarted the landscape into the way it looks now. People returned and gave Fife its names, used the land and the sea to harvest food, built settlements which grew into towns, bridged rivers and firths and gave the kingdom its deep-dyed identity.

For that is what marks out Fife from the rest of Scotland, an absolutely singular sense of itself. With the presence of saints, Andrew, Margaret and the shadows of Ethernan, Serf, Moinenn and others, and the footfalls of uncountable numbers of pilgrims, it became a beacon, a spiritual focus. As the kingdom stretches out into the sea, with its long eastern horizons and big skies, it is not difficult to see how Fife captured souls and brought them nearer to the eternities of God.

And close at hand there flourished an opposite, a culture which took men into the darkness, down and deep into the bowels of the Earth. Where coal seams ran under the waters of the Firth of Forth, miners burrowed after them, and when storms blew hard above their heads, they could hear the thunderous rumble of boulders rolling on the sea-bed. A terrifying sense of a subterranean hell.

When they emerged, blinking into the Fife sunshine, they had the consolation of looking out over beautiful landscapes and seascapes.

These sharp contrasts, drawn over very short distances and contained in single life-spans only serve to colour the identity of Fifers even more vividly. Having a clear picture of where you come from, of who your people were and what they did allows the sons and daughters of Fife to strike out, to take risks, to be creative in business, in the arts, in sport. In Andrew Carnegie, the writers Iain Banks and Ian Rankin, and Jim Baxter, Fife has bred people worthy of the place.

It can be dangerous and diverting to pick out exemplars, people whose lives and work seem to wrap up characteristics in one set of experiences. But few famous Fifers were more Fife than the great musician, Jimmy Shand. From a mining family in East Wemyss, he moved to Auchtermuchty, in the centre of the kingdom. Learning from his father, a skilled melodeon player, Jimmy began to show real promise with the mouth organ and, of course, the fiddle.

170

172

HAAR ROLLING OFF THE SEA AT SUNDOWN

When the time came to leave school and go down the mines, the young musician acquired a motorbike and played at dances in the country places around. Because he had given concerts to raise cash to support the miners' strike of 1926, Shand was banned from returning to the pits after the dispute. Window-shopping in Dundee one day, he went into Forbes Music Shop to try out an accordion. He had no money to buy one, but when the shop owner heard Jimmy play, he immediately hired him as a travelling salesman.

Efforts to become a professional musician faltered at first. The BBC failed Shand's audition because he kept time with his foot but gradually he built a career, until after the Second World War, Jimmy Shand and his band found a loyal and growing audience. It was to be a remarkable time. With more than 330 tunes composed, more tracks recorded than the Beatles and the Rolling Stones combined, and even a Top Twenty hit with The Bluebell Polka, he left an indelible legacy.

Equally unforgettable was the image. In 1962, complete with kilt and supporting band, Jimmy Shand appeared on Top of the Pops. It was extraordinary. His bald head glinted in the studio lights, the heavy-framed glasses hid his downcast eyes and only the flurry of the fingers over the accordion buttons and the tap of his foot showed any animation. Shand's habitual playing position, standing not in the middle but to one side of his band, appeared to underline his diffidence, a lack of interest in anything to do with the show business he had been in all his life. It was the music which mattered, only the music. And it was superb: energy, melody and sheer good cheer flowing out of his accordion. The urge to clap along in time or even get up to dance was hard to resist, and despite his gruff, kirk-elder demeanour, Jimmy Shand was in fact all about having a good time.

Showing characteristic restraint, he retired in 1972 to his beloved Fife and played only small concerts in local village halls when asked to help out with good causes. In 1983 he showed a surprising twinkle of humour when he released an album, The First 50 Years, and accolades of all sorts began to follow. His portrait hangs in the National Gallery and Shand was knighted in 1999. A year later he died.

Many of Fife's extraordinary constrasts and contradictions lived happily alongside each other in Sir Jimmy's life. Modesty and talent, diffidence and extravagance of expression, hard, grinding work and sparkling creativity, a knowledge of the suffocating darkness of deep mining and a love of the open fields and the big skies. Sir Jimmy Shand was a Fifer to the soles of his tapping feet. He knew where he came from, and if Fife remains itself and in control of its destiny, then we will certainly see his like again.

174

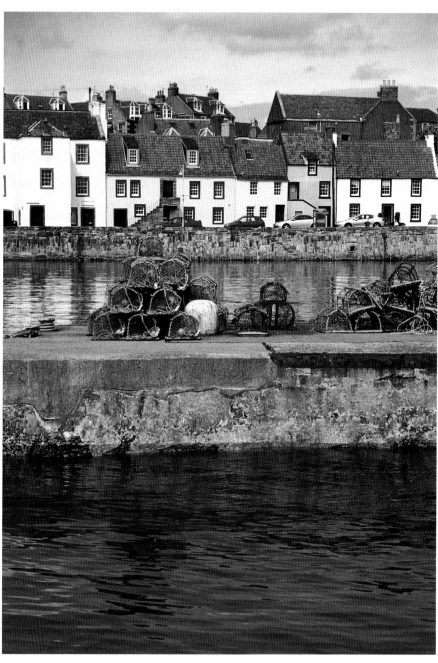